IMAGES
of America

OLD IDAHO
PENITENTIARY

IMAGES
of America

OLD IDAHO
PENITENTIARY

Amber Beierle, Ashley Phillips,
and Hanako Wakatsuki

ARCADIA
PUBLISHING

Published by Arcadia Publishing
Charleston, South Carolina

Printed in the United States of America

Library of Congress Control Number: 2013952070

For all general information, please contact Arcadia Publishing:
Telephone 843-853-2070
Fax 843-853-0044
E-mail sales@arcadiapublishing.com
For customer service and orders:
Toll-Free 1-888-313-2665

Visit us on the Internet at www.arcadiapublishing.com

*To the inmates once confined, the guards who kept them
here, and the volunteers who keep all their stories alive*

CONTENTS

ACKNOWLEDGMENTS

The authors are indebted to dozens of volunteers and professional colleagues who made this book possible. Special thanks go to Meghan Anderson, interpretive specialist assistant, for her enthusiasm and organization; we would have been lost without you. We owe much to the Friends of the Historical Museum and Old Idaho Penitentiary, our support organization. We thank them for helping us make history fun and relevant to all our visitors.

Thank you to the Idaho States Archives, particularly Jenaleigh Kiebert and her volunteers, for assistance with the historic photograph collection. Our extended thanks go to Cheryl Oestreicher, Jim Duran, and Julia Stringfellow, for their help with the *Idaho Statesman*'s photograph collection. Most of the images in this text are courtesy of the Idaho State Historical Society (ISHS) and Special Collections and Archives at Boise State University's Albertsons Library (IDSC-BSU). We are grateful for the assistance and guidance of Rebecca Coffey and the Arcadia Publishing team.

Finally, we thank all the individual contributors to this book. Whether through writing, editing, or the donation of research and photographs, we simply could not have done this book without you: Tricia Canaday, Marc Frisk, Fred Fritchman, Rachelle Littau, Jody Ochoa, and Keith Petersen.

INTRODUCTION

Our goals for this book are to make the history of Old Idaho Penitentiary accessible and to inspire readers to undertake their own historical research. Many of these never-before-seen photographs and their accompanying stories bring about a better understanding of what it was like to work at and be imprisoned in the foreboding fortress at the end of Warm Springs Avenue in Boise, Idaho.

The first chapter addresses how the penitentiary grew from a single plain cell house to an intricate complex of aging and newly constructed buildings. "Rock to Concrete" shows the evolution of construction at the site—from the sandstone Territorial Prison building administered by the US government to concrete structures built by the state.

The second chapter explores how the treatment of prisoners influenced development of the site in "Defining Punishment." Before the turn of the 20th century, inmates breaking prison rules were punished with isolation in darkened cells or in a chamber beneath a cell house called "the Dungeon." A wooden shack dubbed the "Bug House" replaced the Dungeon as a punishment area. In the 1920s, the penitentiary added two new units known among prisoners and guards as the "Cooler" and "Siberia." The Cooler contained six rooms typically holding two to five men in each. Siberia, built three years later, was more traditional solitary confinement, with 12 one-man cells. By 1968, all of these punishment cells were deemed archaic and even barbaric.

Chapter three describes capital punishment at the site. Ten men hanged at the site, but many more narrowly avoided the choking grip of the noose. In 1937, Douglas Van Vlack cheated the gallows by leaping from the top of a prison cell house. Others, like George Levy, relied on 11th-hour reprieves and sentence commutation to save their necks. Still, some faced their fate on the unluckiest of days. On Friday, April 13, 1951, the state carried out the only double execution in its history near the No. 2 Yard entrance at the south wall. Any history of the Old Idaho Penitentiary would be incomplete without the stories of the executions that took place there.

As people moved west and Idaho's population grew, so too did the prison population. In chapter four, "Growing Pains," the effect of steadily increasing prisoner numbers can be seen. New buildings, policies, and ideas in prison reform emerged during this era of change and growth. An increase in the prison population along with reforms advocating separation of inmates based on the severity of their crimes spurred the facility's biggest construction boom in the 1950s. The penitentiary erected seven new buildings and saved the state nearly a million dollars by using inmate labor to construct them. A minimum security facility able to house 320 men was built in 1952, followed by a maximum security cell house in 1954.

Self-sufficiency and reforms arose to sustain the inmate population. Chapter five addresses many reforms and rehabilitation programs, which sometimes proved cost-effective for the warden. Prison officials encouraged raising fruit, vegetables, and livestock for prison consumption and for sale to fund penitentiary operations. By 1938, prison farmland produced "12,000 gallons of vegetables and fruit for the use of the institutions," as well as "6,383 bushels of wheat, oats, barley, and corn

for the use of the institution's livestock," according to the warden's biennial report. Eventually, Eagle Island Farm was also established to employ inmates.

Reforms could only go so far in meeting the prison's needs. By the 1960s and 1970s, the penitentiary showed its age. Steam chases collapsed. Ancient pipes burst, flooding the basement below the kitchen with raw sewage. Inmates and prison officials alike complained daily about antiquated conditions. The sixth chapter explores this era of "Discontent" more closely. Disgruntled inmates used both violent and peaceful means to protest. In 1966, Warden Lou Clapp shut down the commissary after inmates began manufacturing and circulating counterfeit commissary coins. As a result, over 300 inmates participated in a sit-in protest, which began in the "Loafing Room" of the Multi-Purpose Building. It ended in the Prison Chapel after conversations with administration led to the formation of a grievance committee and a promise to reopen the commissary. Damaging riots in 1971 and 1973 further highlighted the need for a modern prison.

While riots, buildings, and prison philosophies offer insight into life at the penitentiary, the stories of guards and inmates reveal the site's most compelling history. Chapter seven focuses exclusively on the people of the penitentiary: inmates, guards, and wardens. Guards often received only minimal training and worked for low pay considering the danger and pressures they faced. In December 1969, Bill Sanders was sent to the penitentiary to be a guard because his job with the Idaho State Police did not receive funding. Lt. Josef Münch gave him a uniform and a name tag and told him he would start the following week. Often, the tales of individual prisoners are even more intriguing. Over 13,000 inmates walked through the doors of the penitentiary. Each one had a unique story, adding greater depth to the understanding of this important place.

The Idaho State Historical Society, a state agency, operates the Old Idaho Penitentiary and for 37 years has kept it open to visitors year-round. All three of this book's authors have worked at "Old Pen." Recently, staff has hosted poetry contests, Friday the 13th tours, Halloween activities, and much more. The true "Legacy" of the site, however, is highlighted in the final chapter of the book. This historical gem in the shadow of the Boise Foothills remains one of the most visited historic sites in Idaho. Over 42,000 visitors walk through the penitentiary every year.

The Idaho State Penitentiary stands as a reminder of the state's evolving ideas of social justice. Nowhere in Idaho is the spirit of the Wild West more present than behind the sandstone walls and steel bars of the penitentiary. Within the walls, built by inmates using the resources from the sprawling hills above the prison, the memory of daring and dastardly deeds of men and women remain for posterity. This book seeks to unlock the mysteries of the prison's century-long story by using rarely seen photographs and little-known stories.

One

ROCK TO CONCRETE

Idaho's population grew steadily through the years as a territory and a state, along with its conviction rates. In its 101 years of operation as a prison, the Idaho State Penitentiary expanded beyond the four acres in the Main Yard, adding various barns and outbuildings, an extended prison yard beyond the south wall, and an additional 1,200 acres of farmland and ranches.

Due to its proximity to a quarry, the penitentiary's early buildings and walls were constructed with sandstone blocks. The results were massive, intimidating structures with thick and secure walls. Beginning in the 1920s, concrete became the building material of choice at the penitentiary because it was less labor intensive and easier to work with.

Old prison buildings aged even as new ones were built. Constant repairs and upgrades were necessary to keep them in livable condition. If they were found to be unfit for habitation, older buildings were often repurposed rather than replaced. One of the oldest cell houses, built in 1899, was gutted in the 1960s to provide space for inmate counseling and other social services. The transition was never completed, but the prison used the space for indoor sports.

On July 18, 1870, the *Idaho Statesman* reported, "[prison construction] is making good progress and before long we will boast of a handsome building . . . and in which any one desiring to pass five years of his existence removed from the noise and turmoil, the cares, responsibilities and vexations of life, can readily be accommodated without charge for board, lodging or clothing." (ISHS 63-104-4.)

Warden John Parley Campbell surveys the progress of the west wall from below Castle Rock. Campbell was warden from 1893 to 1897; he oversaw the construction of the wall, Administration Building, and several buildings within the walls that used stone from the nearby quarry. Warden Campbell implemented the use of inmate labor, keeping the men busy and cutting down on prison labor costs. (ISHS 1241-B.)

Sandstone was used to construct most of the prison buildings, including the wall. Quarrying, carting, and cutting stone kept inmates busy and saved the state material and labor costs. "I find that the constant employment of the prisoners in some kind of work keeps their minds free from plotting and is the best agent for preserving order; this also keeps them in better health," reported the warden in his biennial report in 1894. In addition to quarrying and cutting stone for the penitentiary, inmates dressed stone for the state capitol and soldier's home and used flake remnants to pave the entrance road to the prison. (Above, ISHS 68-57-54; below, 68-57-55.)

Two inmates working in the prison quarry nicknamed the "hill men" cart stone toward the penitentiary. Although many men were anxious to be allowed out of their cells, quarry work was dangerous and laborious. In 1903, while setting explosives, two inmates were killed when a boulder split in two and hurled them to their instant deaths. (ISHS 68-57-49.)

This 1895 false front addition originally housed the penitentiary blacksmith and carpenter shops. It contained all the modern equipment of the time, including chimneys, drills, benches, and two brick forges. Inmates made furniture and even fashioned the bars to their own cells here. Later, this building was used as the prison commissary and yard captain's office. (ISHS 68-57-52.)

A Trusty Dormitory was remodeled into a hospital in 1912. Previously, inmates needing surgery and those with diseases such as tuberculosis and typhoid had to be taken to hospitals in Boise. The prison hospital was used successfully to isolate sickened inmates during the 1918 Spanish flu epidemic. Thanks to a quick quarantine system instituted by the prison physician, only three inmates died of influenza that year. (ISHS 68-57-27.)

These three buildings, added to the penitentiary grounds at the turn of the century, served different functions during the prison's operation. They were known as false front buildings due to the facades that create the illusion of two stories. The buildings housed the library, Trusty Dormitory, hospital, and social services facility. The small building in the center was added as the prison barbershop. (ISHS p5002.2.)

This is the only known image of the completed Territorial Cell House before it was remodeled into the Prison Chapel. The building contained three tiers of cells and was fitted with a tin, mansard-style roof. Declared "unsanitary" and "poorly ventilated" as early as 1909, the aging building was condemned for habitation by the State of Idaho in the 1920s. (ISHS ms511-313-2a.)

This 1950s photograph shows the Prison Chapel. Formerly a cell house, it was remodeled with funds allocated from a Works Progress Administration grant in the 1930s. The prison employed a full-time chaplain; Orvil Stiles, pictured here, conducted Protestant and Catholic services. The chapel also served as a classroom and meeting hall for Alcoholics Anonymous. (ISHS p1986-49.)

An unidentified child stands below the southwest guard tower, also known as the number two tower. The towers were numbered proceeding counter-clockwise from the northwest tower. When the prison expanded, creating No. 2 Yard, officials built two more wooden towers. While the tower in this photograph is unmanned, guards normally occupied all towers during the day. There was no heat or air-conditioning in the towers. Eventually, portable fans and heaters were used. Guards also used a bucket, as no tower contained a bathroom. Trusty inmates came around several times a day to empty the buckets. Guards lowered the buckets down from a rope into the prison yard. (ISHS 1241-A.)

The first Warden's House was located near the original Territorial Cell House. It was later moved outside the prison walls. After the Administration Building was completed in 1894, the warden and his family took quarters upstairs. The small house was converted into a kitchen and dining room for the warden and guards. After 1905, it was used to house female inmates. (ISHS 21-b.)

This stone building served as the warden's residence from 1902 to the 1950s. The home contained eight rooms and a basement. A tennis court, often used by the warden's family, was located next to the building. Over a dozen wardens called this building home in the 50 years it was used. It now houses the Idaho Commission on the Arts. (ISHS 68-57-46.)

Completed in 1907, the Steam Plant produced heat for the cell houses as well as energy to run prison industry. The warden's report that year noted the Steam Plant worked "Very satisfactorily, the entire institution, with the exception of the Women's Ward, being heated by steam instead of with stoves, as was done formerly, and which was found to be very unsatisfactory." (ISHS 73-229-2-dd.)

Inmates built this two-story barn in 1911 from sandstone quarried nearby at a cost to the state of $2,500. Inmate labor and quarried stone saved an estimated $9,500 on its construction. The 70-by-34-foot structure had room for 16 horses and storage for farming implements. The warden proudly stated the "barn has few equals in the state." (ISHS 73-229-2-y.)

In 1912, the warden opined about the wall surrounding the penitentiary. He complained that a November 1911 escape of two inmates could have been avoided by adding height to the sandstone wall. He gave praise to prison hounds for tracking the escapees within hours of their dash to freedom. In this aerial view of the penitentiary, taken around 1915, the expanse around the wall is clear. The photograph also demonstrates the expansion of the facility, with a new cell house under construction. The structure connecting the two wings was eventually removed, leaving two separate cell houses known as North and South Wing, or No. 2 House and No. 3 House. Prison barns and farmland are also visible in the background. (ISHS 68-57-26-6.)

Unmarried guards lived in this handsome 1911 stone building, situated directly across from the Administration Building. It was considered necessary to have some guards available 24 hours a day in case of emergency. Free room and board helped compensate for low wages and dangerous working conditions. Today, the building is used by the College of Western Idaho's horticulture program. (ISHS 68-57-34.)

Many prison staff and their families lived on Goodman Street, behind the penitentiary. Fields provided some distance between the prison and the homes, yet staff was close enough to aid in emergencies. The son of a guard who lived on Goodman with his father remembered convicts building chicken coops and rabbit hutches for his family. (ISHS 72-64-3a.)

Inmates ate communally in the prison's Dining Hall three times a day. They sat front-to-back at long tables to prevent any fraternizing during mealtime. An armed guard stood duty perched in a "bird's nest" on the north wall of the Dining Hall. The building was also used for church services before the Territorial Cell House was remodeled into the Prison Chapel. (ISHS 68-57-25.)

A new cell house is shown being constructed. Maximum Security, held in No. 5 House, had capacity for 20 serious offenders and 5 death row inmates. Maximum security inmates were held in one-man cells for 23 hours a day. They were allowed one hour to exercise in an enclosed yard. Maximum security inmates never left the building and were never allowed to socialize with the general population. (ISHS 1262-jd-a.)

The 1950s ushered in new correctional theories and procedures, generating larger amounts of records and administrative needs. This 1950s building provided ample storage for inmate files, offices, and the prison hobby gift shop, where citizens could purchase goods made by the inmates. Prisoners made simple everyday items as well as ornate pieces of folk art in their down time. Industrious inmates learned new skills in leather making, woodwork, and metalwork, and even honed their own artistic abilities. They paid upfront costs for materials but could keep any profits from the sale of their items. They made purses, canes, cribbage boards, dolls, and shelves, and even had paintings commissioned by art lovers as far away as Arizona. The Idaho Botanical Garden currently uses this building for its administrative offices. (Above, ISHS p1986-49; below, p1984-15-20.)

About 1970, inmate John Larson looks over the elaborate prison complex from the foothills. Many of the outbuildings were whitewashed in the 1960s, including the Administration Building, the 1928 Trusty Dormitory, and the Women's Ward and wall surrounding it. Originally, the prison was well over a mile from the downtown core, but by this time Boise neighborhoods had inched closer to the once isolated facility. After a rash of prison escapes by trusties at the penitentiary and Eagle Island Farm, pranksters went to work. On Halloween 1968, someone erected signs exclaiming, "Crosswalk Yield to Escaping Prisoners." The signs included an inmate in striped clothing with a ball and chain cut loose from his ankle. Deputies with Ada County quickly removed the signs but the joke was not lost on the neighborhoods surrounding the prison site. (Courtesy J. Michael Kurdy, ISHS Collection.)

Two

DEFINING PUNISHMENT

When the Idaho Territorial Penitentiary opened in 1872, nearly all US prisons operated under either the Pennsylvania System or Auburn System. These methods of maintaining prison order dictated everything from forms of punishment to the use of communal spaces. The Pennsylvania System, also known as the "separate system," originated at Eastern State Penitentiary in Philadelphia. Inmates were housed in separate cells, never socializing with other prisoners. They only engaged in handicrafts done in their cells, such as weaving and shoemaking. Developed in New York, the Auburn System, or "congregate system," stressed communal work and separate sleeping quarters. Inmates spent their days working together and evenings alone and silent in their cells to allow time for penitence (hence the term "penitentiary").

The Idaho Penitentiary followed the Auburn System, sentencing inmates to "hard labor." This often meant working long, hard hours in the state quarry behind the prison. When not working, inmates were locked in cells. Although most were two-man cells, silence was strictly enforced under the belief that inmates needed time to reflect upon the actions landing them in the penitentiary. Upon conviction, inmates lost their rights to privacy and identity. They were assigned a number and a uniform of prison stripes, rarely allowed personal possessions, and shared toilet and bathing facilities with other inmates. Punishment included isolation in punishment cells called the "Dungeon," "Cooler," and "Siberia."

Penal practices continually evolved with the times. The Auburn System was all but eliminated from Idaho by the late 1960s and outmoded policies of silence and penitence were replaced by social services and rehabilitation programs. However, vestiges of the Auburn System still remain today. Convict work details and isolation of problematic or dangerous inmates are both reminiscent of that system.

A punishment cell, known as the "dark cell," is visible in the upper left corner. An iron plate covered the cell bars, leaving it dark with limited airflow. An inmate in 1899 was sent to the dark cell for picking a green watermelon without permission. The watermelon was locked up with him. He was released the next morning and had eaten the watermelon. (ISHS 68-57-61.)

Idleness caused unrest, so prisoners not already employed in prison industries were kept busy during the day on various tasks necessary to the facility's operation. Inmates often prepped food for the prison kitchen; these inmates pit fruit in the sally port driveway under the supervision of a guard. (ISHS p1986-49.)

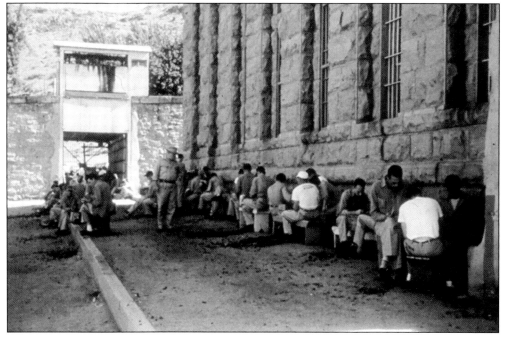

Solitary confinement, known as "Siberia" among inmates, was a punishment area at the Idaho State Penitentiary. Misbehaving convicts were typically held in isolation for 30 days. They were allowed to shower once a week. Warden Orvil Stiles closed the area and removed the individual cell doors in 1967. Punishment then consisted of being transferred to maximum security cells and the revocation of privileges. (ISHS a106.)

Inmates, dressed in prison stripes and hats, listen to a brass band in this c. 1900 image. Warden John Hailey sometimes brought in bands to provide entertainment for the prisoners. Over the years, inmates enjoyed comedy shows, minstrel troupes, local music, movies, and holiday programs. Christmas and Thanksgiving brought large meals, while the Fourth of July was celebrated with barbecues. (ISHS 73-229-2-g.)

These c. 1905 photographs show a new wall built around the women's quarters. The wooden building inside was originally the warden's residence, converted to house the few female inmates previously held in the main prison yard with the men. The small house was replaced with a stone cell house in 1919. The Women's Ward housed a total of 214 female inmates over the years, with only 6 successfully escaping the facility. All female inmates were relocated to institutions in Oregon and Arizona in 1968. Idaho did not build another facility for female inmates until 1994, when it opened the Pocatello Women's Correctional Center. (Above, ISHS 73-229-2-d; below, 68-57-45.)

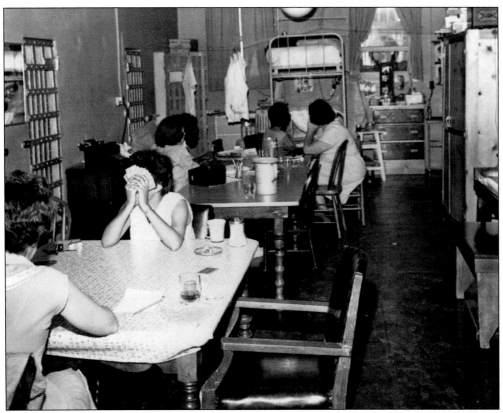

Women were given more freedom than male inmates. This photograph shows women relaxing in their cell house. The building contained 12 two-person cells, but women were sometimes allowed to move their bunks into the hallway if they felt the cramped cells were too confining. Women were also not required to wear prison uniforms, instead wearing street clothes. (ISHS p1984-15-24.)

Inmates in No. 4 House were given more freedom and were sometimes allowed out of their cells to play cards. In the late 1960s, officials let prisoners decorate their cells, believing creative freedom to be part of their rehabilitation. Inmates painted their cells and added decorative features like headboards and floor rugs. (ISHS p1986-49.)

The warden and guards appear to be enjoying themselves as they open Christmas presents sent to inmates by friends and family. Upon arrival at the penitentiary, inmates signed a waiver allowing the warden access to all packages and correspondence addressed to the detainee. Guards screened for weapons, drugs, escape plans, and other illicit materials. (ISHS p1984-15-37.)

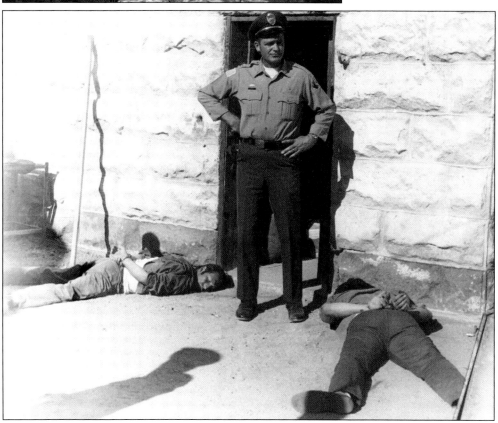

Josef Münch was a yard captain for many years. Born in Germany in 1931, he immigrated to the United States in 1962. A tough, no-nonsense guard, Captain Münch demanded and received respect from inmates and fellow guards. He is pictured here with two hog-tied inmates in front of a building they were attempting to tunnel under. The escape tunnel was about four feet from the prison wall when it was discovered. (Ada County Sheriff's Office.)

Inmates leave the dining hall after breakfast while guards supervise their movements. Breakfast was served at 8:00 a.m.; afterwards, prisoners dispersed to their respective jobs for the day. Loafing and idling in the yard were prohibited; inmates were to report to their duties immediately. These inmates are heading toward the shirt factory and plumbing shop. The inmate wearing all white was likely part of the kitchen crew. (ISHS p2006-18-874a.)

Before the completion of No. 3 Cell House (South Wing), none of the inmate facilities contained indoor plumbing. Instead, cells contained a "honey bucket" for inmates to use as a toilet. Every morning, prisoners left their cells and disposed of the waste in the privy. The buckets dried during the day on racks like the one shown until inmates picked them up to occupy their cells for the evening. (ISHS p1984-15-11.)

Bloodhounds sniffed out escaped inmates. Quickly dispatched, the dogs needed to fix on the scent trail of the escapee before it faded. Fleeing inmates often darted for the Boise River in an effort to lose the hounds. One inmate switched clothing items from three different prisoners in an attempt to outsmart the dogs. He was caught the next day. A June 16, 1902, *Idaho Statesman* article described the hounds as rare "Cuban and Russian breeds" of high quality. "Standing on their hind legs," the article noted, "they look over the high fence that surrounds them and, at the sight of a convict in striped clothes, they split the air with a chorus of howls that are little less than blood-curdling." (Above, ISHS 73-229-2-kkk; below, 68-57-50.)

Early attempts to reform inmates included teaching them new trades or honing old ones like masonry or stone cutting. Here, a prisoner carefully cuts stone pillars believed to be used in the construction of the Idaho State Capitol in Boise. Many prominent homes and buildings in Idaho are made of the sandstone quarried and cut by inmates at the penitentiary. (ISHS 68-57-56.)

While not confined within penitentiary walls, trusties at the Eagle Island Farm still had to perform backbreaking work. Here, they harvest potatoes or onions. Trusties collected the vegetables in sacks attached to their waist. Other inmates prepared the farmed foods, with excess being sold by the Department of Corrections to support the program. (ISHS p1986-49.)

On September 24, 1880, guard J.S. White monitored inmates picking fruit in the orchards south of the prison. Five inmates attacked him, gaining control of his two loaded revolvers. The inmates, including William Reese, took White, farmer Robert Wilson, and Wilson's hired men hostage. The prisoners quickly worked to remove their shackles. Mrs. Wilson, undetected by the frantic escapees, summoned help. A posse of guards and Fort Boise soldiers closed in, and a shootout ensued. The melee left a guard, a soldier, an unfortunate passerby, and Reese wounded. Officials rushed Reese back to his cell, where he confessed his real name was William Trent. He claimed he changed his name to protect the good name of his wealthy family in Illinois. He died a short time later. In this undated photograph, prison dogs watch over the grave of Trent/Reese. Trent's headstone now rests in the prison cemetery, several hundred yards from its original location. (ISHS 73-229-2-hhh.)

Three

HANGING TIMES

The Idaho Territorial Prison in Boise initially operated as a federal facility. The first execution onsite took place on June 28, 1878, when a Native American named Tambiago was hanged. His was also the last federal execution at the prison. Before statehood, most executions took place at the county level. District judges presided over these death penalty cases and, if found guilty, the convicted murderer faced justice in the county where the crime was committed. The 1899 Idaho Legislature passed a law providing that all executions be carried out at the Idaho State Penitentiary, renamed after statehood in 1890.

Idaho's population grew following statehood, and with more residents came more crime. From 1900 to 1929, six executions, all by hanging, occurred in the northeast corner of the prison yard. Death row cells faced the erected gallows, constantly reminding convicted men of their fate.

Between 1929 and 1953, no executions occurred at the penitentiary. In 1957, Raymond Snowden was executed in the No. 5 House gallows. Between 1957 and 2014, Idaho executed three more men. Since the federal moratorium on capital punishment was lifted in 1973, Idaho has used lethal injection as its only method of execution. Historically, the only legal execution methods were hanging and firing squad. The firing squad was never used, and Idaho officially banned its use in 2009.

The People of the United States
vs.
Tambiago (an Indian)

We the Jury in the above entitled action find the defendant Tambiago, guilty of Murder as charged in the Indictment

Robt J Bush
Foreman

The file of Tambiago, the first person and only Native American executed at the Idaho Territorial (and eventual State) Penitentiary, offers little insight into the complexity of his case. This handwritten document spells out the jury's decision plainly. By his own confession he killed an unsuspecting Alex Rhoden, the first white man he saw, in retaliation for what he believed to be the wrongful incarceration of his brother. (ISHS Inmate un-No. 1878.)

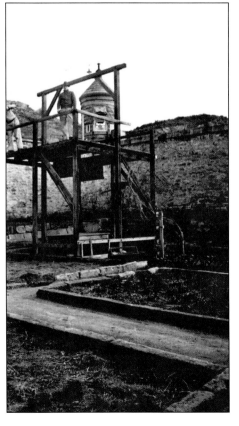

Between 1900 and 1929, prison officials used this gallows, and others like it, to execute six men in the prison's northeast corner. In the 1910s, inmates created a garden in this area. After the warden discontinued the use of the "Dungeon" below the 1890 cell house, officials built a "Bug House" next to the gallows. The wooden shack housed steel cages used for the punishment of unruly inmates. (Bob Olson.)

Jack Davis had no luck when he chased rumors of diamond discoveries near Silver City. But he did acquire a nickname. Diamondfield Jack fared even worse when the Sparks & Harrell Cattle Company hired him to discourage sheepherders from ranging flocks across Cassia County's notorious sheep and cattle deadline. In 1895, Davis wounded sheepherder William Tolman. Fearing murder charges if Tolman died (he did not), Davis escaped to Nevada. There, he spent much of his time boasting about his prowess as a hired gun keeping sheepherders out of Cassia County cow country. When two sheep men turned up dead in the county in 1896, Davis had bragged himself into the role of prime suspect. An Albion, Idaho, jury sentenced him to hang, despite the fact that two other men admitted killing the sheepherders. Wrongly accused, and yet twice scheduled to hang, he received last-minute reprieves. Davis spent nearly six years in jail while he appealed. Gov. Frank Hunt pardoned him in 1902. (ISHS Inmate No. 672.)

In 1900, Ed Rice murdered storekeeper Mat Mailley in Shoshone County. On January 5, 1901, after his incarceration, Rice unsuccessfully tried to commit suicide in his prison cell. On December 1, 1901, Rice became the first man executed after Idaho's statehood. While walking up to the gallows, he repeatedly mumbled, "There is lots of time." (ISHS Inmate No. 788.)

In 1904, Rudolph Wetter killed two miners who had been threatening him in order to take over his mining claim. His attorney used an insanity defense, which Wetter did not agree with, and lost. As preparations for Wetter's execution were being made in August 1906, a reprieve came at the 11th hour on the grounds of case mismanagement. In 1911, his sentence was reduced to 40 years. (ISHS Inmate No. 1044.)

In October 1901, Frenchman George Levy, operator of a house of prostitution in downtown Boise, was accused of strangling Davis Levy (no relation). George Levy insisted he was innocent but was convicted and sentenced to hang. His sentence was later commuted to life in prison. Few believed he was the real murderer, and many people wrote letters asking for a pardon. On the condition of leaving the country, George Levy was unanimously pardoned in July 1911 due to a lack of sufficient evidence. A little more than a year later, Levy was arrested in Portland for white slavery. His arrest was enough to violate his parole and send him to prison for life. (Both, ISHS Inmate No. 854.)

Executed in 1904, James Conners was sentenced for shooting and killing Deputy Sheriff E.P. Sweet and wounding another deputy in Blackfoot. When offered a last drink before his execution, he said, "I was a pretty good fellow when I was sober. Whiskey brought me to where I am and I don't want any more of it." (ISHS Inmate No. 1050.)

In 1906, William "Fred" Bond was hanged for the murder of his lover's husband, Charles Daly. Jennie Daly admitted to shooting her husband, bashing in his head, and finishing him off with a bullet to the heart. She later recanted her story, and a jury convicted Bond, dooming him to the gallows. Convicted only of manslaughter, Jennie Daly received a 10-year sentence. Prisons guards reviled Jennie. (ISHS Inmate No. 1091.)

Executed in 1909, Fred Seward murdered Clara O'Neill. Seward fell in love with O'Neill, a known prostitute. After failing to convince her to move with him, he shot and killed her. Distraught by his horrific act, he shot himself. The bullet did not take his life, but in his mug shot the scars from the suicide attempt are clearly visible on his face. (ISHS Inmate No. 1511.)

John Jurko killed his business partner, A.W.B. Vandenmark, at a pool hall in Twin Falls. Vandenmark had earlier threatened to kill Jurko and made advances towards his wife. Many believed, however, that Jurko, a native of Eastern Europe, did not receive a fair trial because many unfairly associated him with Communism. At his execution on July 9, 1926, he exclaimed, "No mercy, no justice! But I forgive everyone." (ISHS Inmate No. 3416.)

Noah Arnold killed a storekeeper during a robbery attempt. Executed on December 19, 1924, he maintained his innocence but did admit to killing five other men. Moments before his execution Arnold spoke his last words to the prison guards: "Do a good job of it, because I don't want to strangle." He is the only African American ever executed in Idaho. (ISHS Inmate No. 3301.)

Convicted murderer Douglas Van Vlack did not lack supporters pleading for his life to the Idaho Board of Pardons. Letters begging the board to reconsider his death sentence offer a glimpse into his life before his murderous rampage. Regarding Van Vlack, Harold Keller of the Young Men's Christian Association in Tacoma, Washington, noted, "He showed many times that he was a real fellow and a good sport." (ISHS Inmate No. 5264.)

After she filed for divorce, Douglas Van Vlack kidnapped his estranged wife, Mildred Hook, near her home in Tacoma, Washington. He drove through Oregon and stayed overnight in Boise. The next day, Van Vlack killed Idaho state trooper Fontaine Cooper and shot Deputy Sheriff Henry Givens, who died three days later. He shot and killed his wife sometime during that night near a canal in the south central Idaho desert. His family pleaded for his life through letters to the governor. Some guards claimed Van Vlack's mother whispered something in his ear during her last visit to him and that he later exclaimed she told him he could choose the way he died. (Right, ISHS MS511-869; below, MS511-863.)

On December 9, 1937, Douglas Van Vlack was scheduled to hang for the murders of three people, including his wife. After a final embrace with his mother, Van Vlack leaped on a table, pulled himself to the next level of cells, and then up to the top floor. For 30 minutes, guards, Warden William Gess, and Van Vlack's lawyer tried to coax him down. Just as guards prepared to bring in a net, Van Vlack assumed a diving position and jumped. He landed on his head and left shoulder. Coughing up blood and twitching, Van Vlack lived another four agonizing hours. At 12:32 a.m. on December 10, 1937, he died on the cell house floor. Prison officials escorted Van Vlack's body out of the Administration Building and into a waiting hearse after his deadly plunge. (Above, ISHS MS511-864; below, MS511-868.)

On Friday, April 13, 1951, Troy Powell (below), age 21, and Ernest Walrath (above), age 20, were hanged on a temporary gallows built just outside the walls by the No. 2 Yard gate. Powell married Walrath's sister, and the two men often spent time together. The duo set out to rob storekeeper Newton Wilson. While Powell admitted to hitting Wilson, Walrath confessed to delivering the fatal stab wounds. Still, both pled guilty and the judged determined he had no choice but to exact the ultimate punishment. Powell and Walrath are the youngest inmates ever executed in Idaho and it was the only double execution in the state's history. The two men are buried next to each other at Morris Hill Cemetery in Boise. (Above, ISHS Inmate No. 7987; below, No. 7986.)

On September 22, 1956, Raymond Snowden brutally murdered Cora Dean in Garden City, Idaho. After drinking and carousing at a bar, the pair decided to go to downtown Boise. Snowden claimed a physical altercation ensued about who would pay the cab fare. Dean allegedly kneed him in the groin, sending him into a murderous rage. The judge said Snowden possessed a cold-blooded and "malignant heart." While imprisoned, Snowden wrote letters to his family in Massachusetts. He filled his days with crossword puzzles and occasionally visited with the prison chaplain. On October 18, 1957, just 13 months after the crime, an executioner brought in from Walla Walla, Washington, pulled a lever, releasing the trap door beneath Snowden's feet. The execution was the first and last one in the No. 5 Cell House/Maximum Security Gallows. The last man executed at the Idaho State Penitentiary, Snowden is buried in the prison cemetery. (ISHS Inmate No. 9509.)

Four

GROWING PAINS

In March 1872, eleven inmates were transferred from the Boise County Jail in Idaho City to the new federal territorial penitentiary in Boise, Idaho. The prison population peaked at just over 600 inmates in the late 1950s. Increased incarcerations resulted in additional economic, logistical, and political-social problems. Over time, prison officials changed disciplinary procedures, expanded the prison yard, and created prison industry opportunities to meet the demands of a growing population at the Idaho State Penitentiary.

Sanitation and water supply were a constant struggle at the penitentiary. The two earliest cell houses, sarcastically known as "bucket houses," were never equipped with toilets or sinks in the cells. Inmates instead used "honey buckets" to relieve themselves. Sewage lines installed in the Dining Hall and other buildings frequently broke, flooding the basements with raw sewage. Fresh water was drawn initially from a natural hot springs reservoir behind the prison. As the only source of water, the hot springs even irrigated the vegetable fields. In 1907, a diversion dam was built on the nearby Boise River, providing a new, more sustainable water source.

Through all of its growing pains, the Idaho State Penitentiary remained largely self-sustaining. Inmates raised and prepared their own food, built the majority of the prison's buildings, washed their own clothing, and ran the steam plant that provided heat to the cell houses.

By the early 1960s, the prison was showing its age. Plumbing and electrical problems plagued the institution, antiquated cell houses were small and lacked modern amenities, and the growth of Boise City had virtually landlocked the prison, leaving no room for further expansion. As much as Idaho had worked to update and expand its penitentiary, officials finally sought a new location to build a modern facility.

A sally port is a controlled entryway, usually with two locking gates, only one of which is opened at a time. The Idaho State Penitentiary added its sally port in 1931 to help move goods and inmates in and out of the facility. All incoming and outgoing vehicles were locked in the sally port and thoroughly searched before being allowed to proceed. Before the sally port was constructed, all supplies and materials had to be transported through a tunnel in the Administration Building. The narrow, dirt-floored tunnel was too small for most automobiles and posed security risks. (Above, ISHS 76-180-2a; below, p1986-49.)

In July 1956, inmates finished construction of the new Visitation Room. Located next to the penitentiary's existing Administration Building, it expanded the previous small one-room area into a much larger open room with 28 visitation stalls. Between 1951 and 1956, inmates assisted in a massive construction program at the penitentiary, completing seven buildings, including two new cell houses, a new Administration Building, and a heating plant. By using inmate labor, the project saved the State of Idaho an estimated $800,000 in construction costs. The building now serves as a restroom area for Old Idaho Penitentiary visitors year-round. (Above, ISHS p1986-49; right, 76-160-354.)

In the 1950s, the penitentiary expanded the prison beyond the main wall into an area known as No. 2 Yard. The expansion included industrial and educational buildings, a new social service complex, and sport fields where inmates played baseball and football. The photograph above shows prisoners entering No. 2 Yard through the south wall. The yard was monitored by two guard towers and enclosed by a double cyclone fence. All inmates were subject to search upon entering or exiting the No. 2 Yard gate. Still, many managed to sneak in metal and tools to use as makeshift weapons. One inmate even smuggled Dennis, the prison cat, through the gate from an outbuilding. (Above, ISHS p1986-49; below, p5002-2.)

Ridiculed as showy and called the "House of Seven Gables" by some, the new Warden's House was built in the 1950s. Longtime warden Lou Clapp and his family moved into the new building in 1954. The property was last occupied by Warden Raymond May and is now operated by the Idaho Department of Corrections. (ISHS p1984-15-555.)

Inmates maintained vegetable fields at the prison farm, known as the Mosley Farm, located less than a mile from the penitentiary. A 1940 report from the Idaho Prison Commission regarded the acreage as "intensely farmed and . . . at present highly productive." Warden John Snook originally rented Mosley Farm in 1910, and the positive experience convinced him to expand the prison's agricultural operations. (ISHS p1986-49.)

Fresh green peas were the object of an intense week-long operation at the prison in July 1953. Five acres were picked, shelled, and canned in what Warden Lou Clapp dubbed "Operation Canned Peas." Sudden hot weather caused the peas to ripen very quickly and all outside work was suspended to complete the harvest. Harvesting the crop before it shriveled in the heat required 200 diligently working men. Inmates canned peas at a rate of about 3,600 pounds per day. The prison canned 25,200 pounds of peas by the end of the week. Wasting nothing, excess pea pods were fed to prison hogs. (Above, ISHS a-105; below, p18-3-2.)

By 1953, inmates canned an average of 30,000 gallons of fruits and vegetables each year. In 1956 and again in 1959, the prison warden beseeched the legislature for more canning equipment. The warden also recommended building a cannery within the walls. The legislature never granted these requests. By 1962, the cannery program employed 45 inmates seasonally for about six months each year. (ISHS p1984-15-35.)

Inmates dressed in their prison blues are forced to sit in the sally port around 1950 and peel what appear to be apples. While some inmates did not work in prison industries, most preferred any kind of labor to the monotony of idleness. These mundane jobs were often a means of punishment for prisoners who misbehaved. (ISHS p1986-49.)

Eagle Island Farm was purchased in the 1930s for $75,000. Inmate labor turned the 500 acres of rocky, sandy ground into a productive livestock ranch, complete with a dairy, hog pens, slaughterhouses, and cultivated land. The ranch produced all the meat and dairy products the prison required and also profited from the sale of any surplus. (ISHS p1986-49.)

Inmates who worked at Eagle Island Farm lived in this Trusty Dormitory. Trusties were considered trustworthy and were often allowed to work and live outside prison walls. They were usually appointed to specific work details. Many used the relative freedom to earn "good time" and perhaps an early parole. Others took the opportunity to attempt escape. (ISHS p1986-49.)

General population inmates typically had two hours of leisure time every afternoon before evening lockdown. Men could play games or sports, shower, make crafts, or just relax. Many inmates spent their free time in the Multipurpose Room, particularly during inclement weather. These men are enjoying card games and conversation. (ISHS p1984-15-7.)

Inmates used these outdoor prison toilets during working and recreation hours. For the most part, prisoners were not permitted in their cells during the day. These antiquated bathroom facilities were used until the prison closed in 1973. Just beyond the toilets, the Multipurpose Building, once home to the Shirt Factory, housed the loafing area, recreation center, laundry, and plumbing shop. (ISHS 75-5-82.)

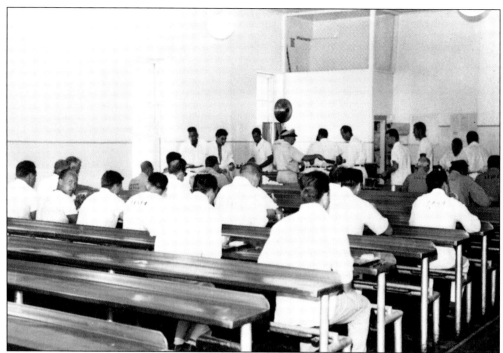

From the time the Dining Hall was built in 1898 through the end of the 1960s, inmates ate at long tables facing one direction and in complete silence. During meal times, a guard could sit in a caged perch, known as the "Bird's Nest," overlooking the Dining Hall. In 1935, despite the presence of guards, a riot took place in the Dining Hall and was the first time a warden used tear gas to quell chaos. In the 1950s, renovations included stainless steel tables and benches. In 1964, the kitchen served 350 men per hour. More than 35 inmates worked in the kitchen and Dining Hall. (Above, ISHS p1984-15-12; below, ISHS Collection.)

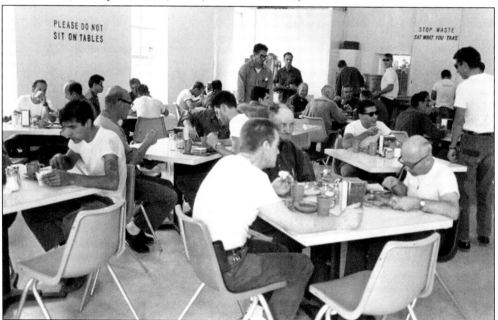

Five

REFORMING WAYS

Finding productive work to keep prisoners from being idle was a constant source of concern and frustration for prison wardens. Idleness led to mischief, something penitentiary administrators wanted to avoid. In 1909, Warden John Snook remarked, "Nothing could be worse in a prison than keeping the prisoners without providing work for them." Early work efforts such as construction, farming, and making clothing focused primarily on supporting the prison itself. Over time, however, they failed to fully employ the ranks of able-bodied inmates. Prison officials sought alternatives that provided predictable, consistent work and a source of regular income to help support prison operations. By 1924, Snook boasted, "every able-bodied, physically fit inmate of the Penitentiary is employed in useful labor." Of the 253 inmates at that time, 170 worked in the prison's shirt factory.

The goal of keeping inmates occupied and out of trouble resulted in the establishment of prison libraries, schools, and chapels. At first, these were typically located in appropriated spaces, but as facilities expanded, dedicated space was often built. In the early 1950s, an ambitious construction project produced seven new buildings using mostly inmate labor at a great savings to the state, keeping inmates both working and learning new skills.

By the 1960s and 1970s, inmates experienced more opportunity for educational and vocational training than ever before. Aging and antiquated facilities made it difficult to provide educational opportunities for an ever-growing prison population. This problem influenced the closure of the prison and guided development of the new state penitentiary.

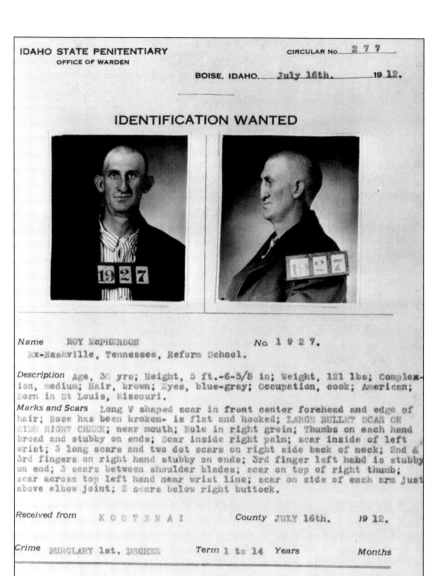

The French method of identification, known as the Bertillon system, was adopted by the Idaho State Penitentiary in 1912. The process included full face and profile photographs, as well as height and weight measurements and documentation of all physical characteristics. An inmate's Bertillon chart noted moles, crooked and rotting teeth, scars, wounds, skin conditions, and tattoos. This system made it easier to identify escaped inmates and inmates attempting to use an assumed name. It was widely used until fingerprinting became available as a more reliable identification method. Featured in this document is inmate 1927, Roy McPherson, also known as Harry McPherson. A cook by trade, McPherson was convicted of burglary in the first degree in Kootenai County. Received at the penitentiary in 1912, McPherson's inmate file includes a lengthy description of scars and identifying marks across his body. This profile mug shot reveals his most distinguishing facial feature—a severely pressed nose. (ISHS 79-2-22.)

Less than a decade after the Idaho State Penitentiary adopted the revolutionary Bertillon system, it was considered obsolete. The penitentiary replaced it with fingerprinting, which proved to be a more effective means of tracking inmates and also helped monitor crime nationwide. In 1934, "mirror photos" replaced the practice of taking two mug shots: frontal and profile. Here, Al George, inmate 10037, demonstrates the steps new inmates went through before ever occupying a cell. The mirror allowed for one photograph to serve as both a frontal and profile mug shot. The process took place in the warden's office initially and was later moved to the new Administration Building in the 1950s. (Both, ISHS p1986-49.)

Before the completion of a formal visitation room in 1956, visits were held in an inmate's tiny cell or a small office in the Administration Building. The new area, complete with washrooms and drinking fountains, contained 28 visitation stalls. Strict rules still applied. Only relatives could visit, and only between 9:00 a.m. and 11:00 a.m. or 1:00 p.m. and 3:00 p.m. Prison officials allowed inmates one visitor per month, and conversations were monitored by guards. Like all privileges, inmate visitation rights could be revoked. In the late 1960s, Warden Orvil Stiles removed the stalls, put in tables and chairs, and stopped the practice of listening to all conversations. (Above, ISHS p1984-15-14; below, p1986-49.)

On June 7, 1937, while en route to the Portland Rose Festival, Victor McLaglen's Motorcycle Corps performed stunts inside the Idaho State Penitentiary, much to the delight of inmates. The *Idaho Statesman* reported 13 riders dressed in "snappy" blue uniforms also played with the prison band and "enjoyed themselves" during the visit. They also performed near the Idaho Capitol Building, Julia Davis Park, and in front of Boise's old city hall. The *Idaho Statesman* described the corps "spread-eagled all over Boise and in 15 minutes had the younger generation at their heels." In 1935, professional actor and stuntman Victor McLaglen started the motorcycle stunt group; it is still active today. Before its visit to Boise, the group had never performed stunts inside prison walls. (Right, ISHS m511-955; below, m511-776.)

In 1940, Warden Gilbert H. Talley stated, "The tax payer should not be compelled to support these men in idleness when they want to work." The license plate factory, run entirely by Idaho State Penitentiary inmates, saved the state approximately $50,000 each year. In 1952, plates and replacement tabs were manufactured for 8¢ and 3¢ each, respectively. (ISHS p1984-15-16.)

An inmate in the Tag Plant prepares a shipment of license plates going to one of Idaho's 44 counties. Manufacturing license plates, also known as tags, provided occupational training to inmates and cut costs for county and state governments. Between July 1, 1960, and June 30, 1962, inmates produced 1,922,804 license plates in the No. 2 Yard Tag Plant. License plate making continues today at the current prison. (IDSC-BSU 1962.)

When an inmate arrived at the Idaho State Penitentiary for incarceration, officials noted his or her occupation for official records. In 1933, for example, the inmate population included a former "ball player," "radio man," and "vulcanizer." The overwhelming majority, however, listed previous employment as "farmer" or "laborer." The inmate population's lack of work skills necessary to provide lasting employment and thus stay out of trouble prompted prison officials to revolutionize the prison industry. By training inmates and giving them new skills, the state also saved money on food, construction, and services. Here, inmates operate heavy sign-making and manufacturing equipment in the 1960s. (Above, IDSC-BSU 1962; below, ISHS p1986-49.)

This staged photograph of a baseball game, entitled "A Close Decision," highlights the importance of recreation at the Idaho State Penitentiary. Taken about 1912, the photograph also reveals the evolution of prison construction and deconstruction. A facade, clearly shown to the left, connected No. 2 and No. 3 Houses (also known as the North and South Wings) for decades. It was designed to be one large cellblock, but the state never secured funds to finish the original design. Finally,

ISION.

ITENTIARY.

the facade was demolished, creating two separate buildings. The picture also captures inmates watching the baseball game from the stone shed, where they cut and prepared stone that officials sold to the state and private companies. In 1952, with the help of inmate labor, construction was completed on the No. 4 House, located where the shed once stood. (ISHS 68-57-47.)

The 1913 prison baseball team posed with the Boise Irrigators. James "Jimmie" Whitaker, the second-youngest inmate ever incarcerated at the penitentiary, can be seen sitting at left in the front row wearing a white uniform. At age 11, Whitaker shot and killed his mother at close range after she disciplined him for disobeying her command to do laundry work. His young age and gruesome crime disturbed and baffled many Idahoans. Concerned for Jimmie's health and stability, Warden John Snook arranged for a visit into Boise to see a doctor and dentist. While in town, the warden purchased a baseball and mitt for the young inmate. Baseball seemed to calm the boy's outbursts, proving an effective outlet for his anger. Whitaker's cellmate and informal guardian, Barney O'Neil, helped teach the boy manners and self-control. In June 1914, O'Neil recalled calmly reminding the lad, "Nobody can play baseball who loses his temper." (ISHS 68-57-33.)

A former opposing player remembered the Outlaws as "The best team I ever played against." Prison baseball teams organized as early as 1897. Around 1930, the Outlaw baseball team officially formed, and any inmate could try out for the team, including convicted killers. The Outlaws played teams from throughout the area. When three players attempted to jump a train en route to a game in a nearby city, it led to a schedule of mostly home games. On June 5, 1937, the *Idaho Statesman* quipped about the team, "Living up to their reputation, the Outlaws of the Idaho penitentiary stole enough bases Saturday afternoon to defeat the Deer Flat CCC camp baseball team 5-3." Outlaw Field moved from its original location inside the prison yard to No. 2 Yard in the late 1940s. (Above, ISHS p1992-2-1; below, p1984-15-21.)

Businessman Ivan Strand (52) donated this photograph to the Idaho State Historical Society, explaining that his flag football team borrowed uniforms from Bishop Kelly High School and challenged inmates to a game in 1969 or 1970. "The visiting team included 2 probation officers and 2 public defenders, just to add spice to [the] game," noted Strand. Both quarterbacks suffered broken bones, and the visitors won 12-6 in overtime. (ISHS p5002-2-4.)

Many recreational activities moved to No. 2 Yard in the 1950s. Here, shirtless inmates play a game of pickup basketball. In the background, homemade weight sets and barbells rest on the ground. Inmates did not want to appear weak and often lifted weights to improve their physiques. To the right, a batter steps up to the plate during an Outlaw baseball game. (ISHS p1986-49.)

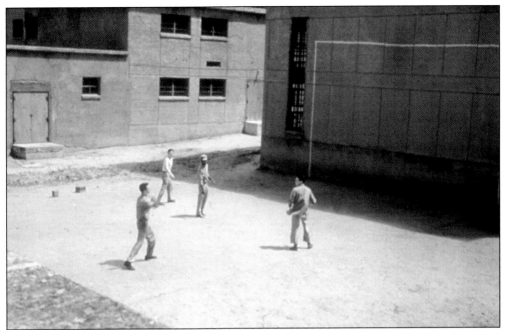

On the west side of No. 4 House, inmates created a handball court using the wall of the building. Most inmate games were allowed by prison officials. Gambling on the games was strictly forbidden, but it did not stop some prisoners from betting meals, cigarettes, or other everyday items on a match's outcome. (ISHS p1986-49.)

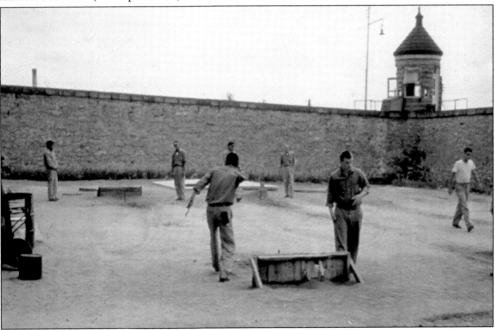

Inmates constructed a series of horseshoe pits in the southwest corner of the prison yard under the careful watch of the guard tower. Similar to horseshoes, quoits was one of the first formal games played by prisoners. In quoits, a ring/disc is thrown from a set distance at a spike. The goal is to get the ring over the spike or be the closest to it. (ISHS p1986-49.)

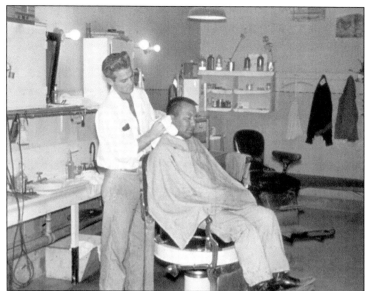

Prison officials created an inmate library but strictly screened books for content. No "salacious" or "lewd" books were allowed. The 1931 rules stated, "You will not be allowed to retain any one book for a longer period than two weeks. . . . Wilfull [sic] mutilation, defacement or destruction of a book will be punished according to the gravity of the offense." (ISHS p1984-15-23.)

Built in 1902, the barbershop closed in the 1960s due to the illegal exchange of contraband in the building. As a result, prison officials decided to designate one barber for each cell house, so all of an inmate's grooming needs were provided in individual cell houses. By 1972, a strict set of standards existed for sideburns, mustaches, and hair lengths. (ISHS p1986-49.)

Chapel services were held for both Catholics and Protestants. After some debate in the community, the warden allowed Latter-day Saints services. The chapel also served as a meeting place for Religious Quest classes and Yokefellows Group. Led by citizen sponsors, Yokefellow inmates prayed and discussed matters of faith and personal experience. Entry to this group was by chaplain invitation only. By the early 1950s, inmate James "Blueagle" Erard completed several murals in the chapel depicting the life of Jesus. Word of his artistic talent spread throughout the state and even across the country. His file reveals that people as far away as Arizona commissioned pieces of his art. (Above, ISHS 75-2-72; right, Inmate No. 7018.)

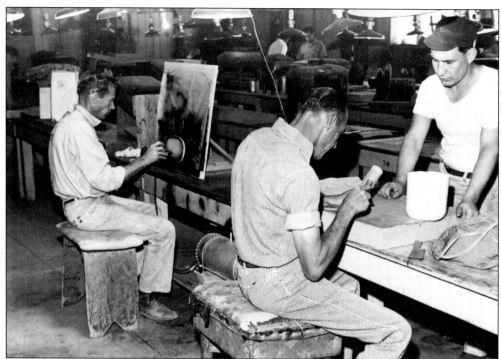

Working hard for the "bulls" (guards) had its rewards. Inmates received incentive credits for outstanding work reports, attending school or college classes, seeking counsel (clinical services, chaplain, and so forth), and for participation in prison clubs and organizations, including Jaycees, Gavel Club, Hobby Craft, Inmate Council, and Entertainment Club. The Incentive Awards program consisted of five levels based on a point system. At the first level, with just five points, inmates could receive either a steak dinner with all the trimmings or a three-minute telephone call paid for by the state. The highest level, at 30 points, provided several options including $20 in the inmate's account, a free magazine subscription for a year, or a party in the Visiting Room with four approved outside guests. All inmates with the exception of those housed in maximum security could participate. (Above, ISHS p1984-15-5; below, p1984-15-15.)

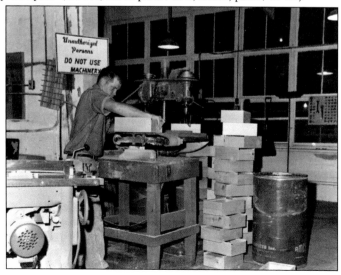

A sign boasts "Souvenirs made by the inmates" and "Xmas gifts" in a hobby shop display at the prison Administration Building. Inmates constructed walking sticks, jewelry, bags, and other crafts during down time to sell to Boise citizens. Money earned through the sales was entered into an inmate's commissary credit, which could then be used to purchase items like tobacco and candy. (ISHS 68-57-31.)

Even hardened criminals wanted to help children during the holiday season. Inmates assisted in several charitable projects at the penitentiary like the US Marine Corps' annual Toys for Tots program. While only approved inmates could participate, they still diligently fixed toys and constructed new ones to donate to the toy-collecting venture. (ISHS p5002-2-1.)

After the 1894 construction of the false front buildings, prison officials opened a commissary shop in one of the sandstone structures. Inmates earned commissary coins, originally made from pressed leather and later from green plastic, by working in different prison industry jobs. In 1966, the warden discovered a counterfeiting ring involving several inmates and the precious coins. As a result, he briefly closed the commissary, frustrating the inmates. He reopened it after inmates protested in a peaceful sit-in demonstration. He instituted a credit system, abolishing the commissary coins. In 1972, inmates could purchase no more than $40 worth of items in the commissary per month. Unless they received special permission, inmates were only allowed items and belongings from the commissary. (Above, ISHS 68-57-28; below, p1986-49.)

In July 1907, while tending to the prison bees, inmate Charles Peterson asked a guard if he could retrieve a lost swarm in the rocks above the penitentiary. Granted permission, Peterson never collected the bees, instead making a beeline for the foothills. Peterson, just 22 at the time, suffered from bee stings, nearly swelling his eyes shut. He was captured a month later in Garden Valley. In June 1927, the *Idaho Statesman* reported on the progress of the penitentiary's bees. "Forty stands of bees take advantage of the flowering vegetation," exclaimed the article, "and in return for the privilege satisfy the sweet tooth of the men confined for mistakes which they have made." The apiary rested at the base of the foothills near the cemetery. (Both, ISHS p1986-49.)

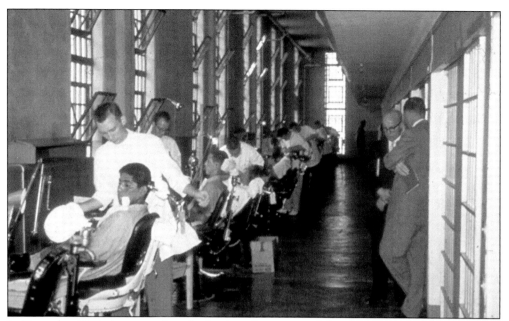

In December 1905, six recent dental school graduates visited the penitentiary asking for inmate volunteers. The dentists needed to perform exams in order to be accepted by the state dental board and begin their practices. In the 1940s, a dentist visited the prison once a week. In the 1950s, state dental board exams continued to be held at the penitentiary, fulfilling professional requirements while providing care to inmates. (ISHS p1986-49.)

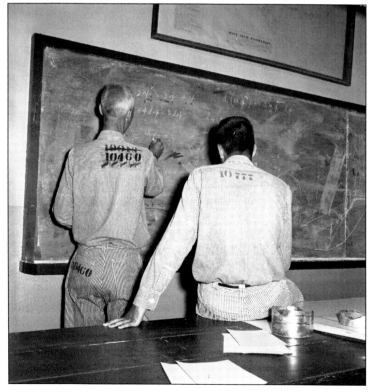

Inmates Walter Malchow (standing) and Kenneth Strother work on math problems at the penitentiary's educational facility. Local high schools provided diplomas to those who successfully completed 16 credits in the required subject areas. Staff included an education director, several volunteer teachers, and often some college-educated inmates. On average, about 30 high school equivalency diplomas were awarded each year. (IDSC-BSU 1962.)

IDAHO STATE PENITENTIARY.

In 1917, industrious inmates began a flower and vegetable garden in the southeast corner of the prison yard. The garden included a stone fountain cut by prisoners. It soon expanded to the northeast corner, where six executions occurred from 1901 to 1929. By 1927, inmates abandoned the southeast garden when the punishment cells known as the Cooler and Siberia were completed. (ISHS 63-98-5.)

Located below the main kitchen in the Dining Hall, the bakery expanded over the years. Inmates improved on and learned new bakery skills. The bakery did cause unintended problems. On June 22, 1898, inmate Philip Clifford spent the night in the "dark cell" for stealing yeast from the bakery to make his own beer. Inmate bakers sold their pastry perfections in the prison commissary. (ISHS p1986-49.)

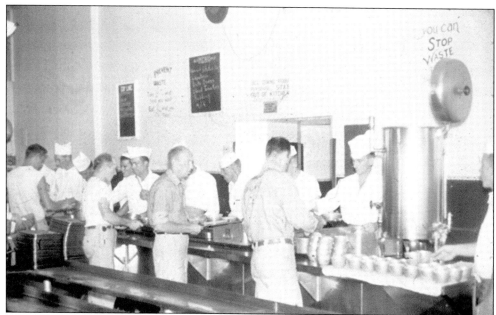

Strict Dining Hall rules did not change much over the years. In 1931, rules clearly stated inmates should not speak at any time, nor laugh or make eye contact with anyone, and had to march in line directly to their designated seats. The rule book also made clear, "Wasting food in any form will be punished." Designated bins held knives, spoons, forks, and trays to prevent inmates from stealing items for making weapons. Inmates performed Christmas programs and minstrel shows in the building through the 1930s. In the 1970s, officials allowed for communal tables and minimal talking in a dramatic change from nearly 100 years of prison dining etiquette. (Above, ISHS p1986-49; below, ISHS Collection.)

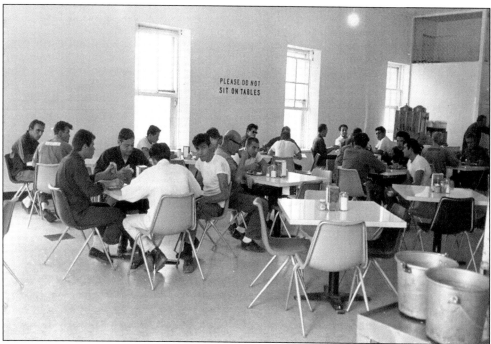

Six

DISCONTENT

While small disagreements between inmates and prison officials regularly occurred, only seven major disturbances (1910, 1935, 1952, 1958, 1966, 1971, and 1973) rocked the penitentiary. These led to very few changes in the lives of the inmates who caused them but sometimes changed policy and procedures within the prison system. Of these seven major conflicts at the Idaho State Penitentiary, only three caused significant damage to buildings.

In 1910 and 1935, inmates used force to attempt to effect changes in the prison diet. The November 19, 1935, disturbance started when six angry inmates threw dishes, food, and tables in the Dining Hall. Warden Ira Taylor became the first to use knockout gas to quiet the riot. Taylor blamed the whole affair on inmate idleness after the Shirt Factory Building closed due to violations of US labor laws.

In February 1966, the only peaceful sit-in occurred at the penitentiary. Prisoners protested the closure of the commissary. The most costly and damaging riots, however, occurred in the final years of the penitentiary's operation. In both the 1971 and 1973 riots, official reports primarily blamed deteriorating conditions in the aged facility and inmate-guard relations for the conflict and damage. The riots left the chapel, dining hall, and hospital destroyed by fire.

Everything from overcrowding, accusations of civil rights violations, and even food initiated some of the most violent unrest in the prison's history. The lasting effects of riots can be seen in the burned-out shells of buildings left on the prison site. In the long term, these events led to the professionalization of corrections, including better training for guards and new procedures for prison officials in hostile situations.

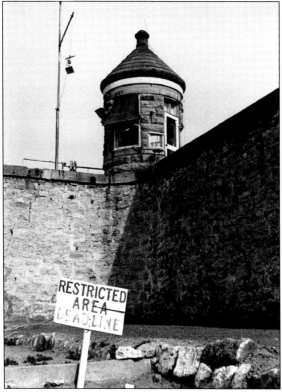

On April 19, 1910, six prisoners broke away from their quarry detail and stormed Warden John W. Snook's office. Hearing the disturbance, Snook pulled his revolver from his desk and waited. Upon questioning, the inmates claimed to be a grievance committee appointed to raise the issue of "rotten food, particularly the meat." Snook acknowledged the prison had been on "high discipline" due to "escape attempts and prisoner tension." (ISHS 73-229-2-a.)

A 20-foot area of dirt and rocks, commonly referred to as the "deadline," separated the wall from the Main Yard. Raked daily by inmates, the area served as a buffer for any hurried escape attempts. Newly arrived inmates, known as "fish," learned quickly to stay clear of the deadline without first receiving permission. If found in the area, inmates received a verbal warning; deadly force came next. (ISHS A108.)

On May 24, 1952, almost 250 prisoners seized control of the Multipurpose Building, seen here. They were protesting Warden Louis E. Clapp's failure to consult the new inmate grievance committee regarding four inmates in solitary confinement. During five hours of negotiation, almost 100 guards, police, and volunteers kept their weapons trained on the prison yard. With no peaceful resolution in sight, Clapp ordered his men to fire tear gas into the crowded complex. Although no violence occurred during the melee, the Multipurpose Building suffered heavy damage and remained out of commission for weeks. In a press conference following the insurrection, prisoners Roy Edward Jones and James Miller leveled accusations of abuse against Capt. Gilbert Talley. They declared his incarceration of the four men in solitary unjustified. Warden Clapp refuted this claim and put the entire facility in lockdown. Soon thereafter, he abolished the inmate grievance committee. (ISHS p1984-15-32.)

On September 15, 1953, inmate Roberto Samaniego (below), unprovoked and brandishing a razor, attacked Frank Lane (left) in the Dining Hall line. As Samaniego frantically thrust the blade, an unidentified inmate tossed Lane a knife to defend himself. Lane then fatally stabbed his attacker. Several inmates claimed Samaniego was seeking revenge against Lane. After a formal investigation, penitentiary officials determined Lane interrupted Samaniego days earlier as he attempted to assault another inmate in the Prison Chapel. Other inmates testified Samaniego sexually preyed upon a young inmate and, fearing retribution or discipline, attacked Lane to ensure his silence. No one ever confessed or informed officials who tossed Lane the weapon that protected his life and ended Samaniego's. (Left, ISHS p5002-2-83; below, Inmate No. 8215.)

Inmates are shown loafing in front of the Multipurpose Building, where the penitentiary gym and boxing ring were located. In the 1890s, prison officials received sharp criticism for allowing boxing matches between inmates. By the 1960s, however, boxing and other sports were strongly encouraged. The inmates dubbed their boxing club the Warm Springs Boxing Association at Park View Gym, as seen above the door. (IDSC-BSU 8/10/1971.)

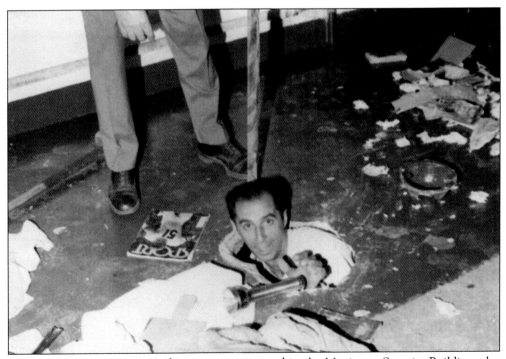

Lt. Louis J. Yaconetti emerges from an escape tunnel in the Maximum Security Building, also known as No. 5 Cell House. The tunnel started at a shower drain and extended at least 10 feet underground. Stacked magazines, placed under the drain by inmates, kept it level at the surface and unnoticed for months. (IDSC-BSU 1971.)

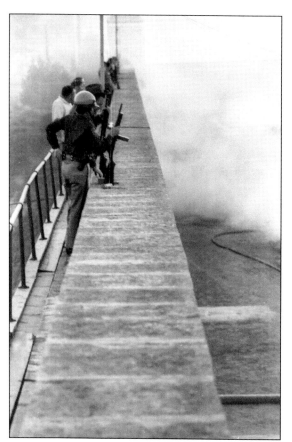

Armed prison guards along with local and state police watch smoldering buildings during the 1971 riot. Officials shot three rounds of tear gas into the recreation area in an attempt to disperse the inmates and prevent them from lighting more fires. Shortly after, Warden Raymond May ordered all guards off the wall while he entered the yard to negotiate with an inmate council. (IDSC-BSU 8/10/1971.)

In 1971, heated exchanges included insults between inmates and reporters, police officers, guards, and even the warden. Here, one shirtless inmate appears to call out to *Idaho Statesman* reporters on hand. Assistant superintendent for programs Glen Jeffes is seen in the center of the photograph, back turned with a black shirt, trying to listen to inmate concerns. Broken windows in the gymnasium are clearly visible in the background. (IDSC-BSU 8/10/1971.)

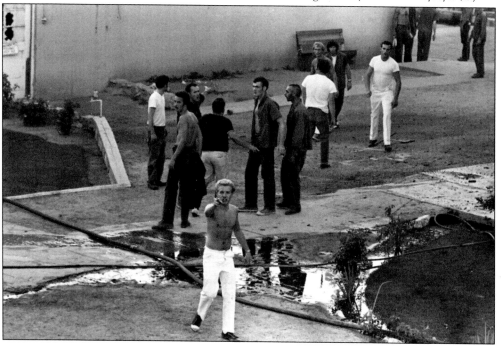

Fires rage in No. 2 Yard during the 1971 riot. The social service building was the first to ignite, followed by fires in the hobby shop and bakery. During the three-hour disturbance, several buildings were damaged by fire, and two prisoners were stabbed by other inmates. Inmates also stole drugs from the hospital's "hot box" and grilled steaks in the prison yard. (IDSC-BSU 8/10/1971.)

Firefighters feverishly attempt to put out the mounting flames in the old hospital building. No longer utilized as a hospital, it served as a storage facility for medications. Inmates quickly overran the building, dubbed the "hot box," in order find and use prescription drugs. A short time later, it was set on fire. (IDSC-BSU 8/10/1971.)

William "Bill" Butler, above, convicted of rape and murder, was no stranger to confrontations at the penitentiary. His inmate file indicates he visited the prison hospital in October 1968 with a head injury after being struck with an iron pipe. In April 1969, he was involved in an altercation with another inmate in the prison's license plate factory. On August 14, 1971, a guard discovered Butler's body in the prison gym inside the Multipurpose Building. In November 2013, Ronald Macik, Butler's confessed killer, recanted his confession. He admitted to bringing Butler to the area where he died but not killing him. He also maintained that former Ada County prosecutor Jim Risch coerced his confession. Risch adamantly denied the accusation and responded, "Ronald Macik was probably one of the worst guys I ever prosecuted. He was a bad, bad person." (ISHS Inmate No. 12127.)

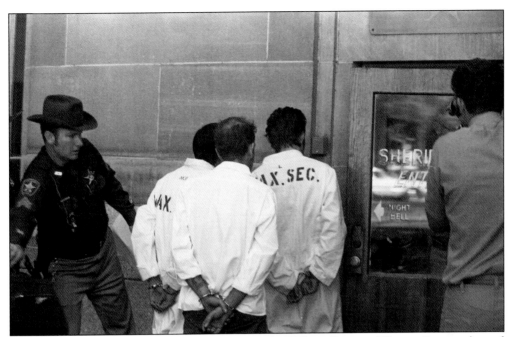

Following the 1971 riot, inmates Ronald Lee Macik, William Burt, and Danny Powers, charged with the murder of fellow inmate William "Bill" Butler, are transferred to the maximum security quarters at the new correction site. Butler's body was discovered rolled up in an exercise mat in the Multipurpose Building five days after the riot. (IDSC-BSU 8/23/1971.)

An unidentified guard from the early 1970s poses for a photograph on the wall overlooking the Rose Garden, Dining Hall, and new cell house. Working conditions for guards remained dangerous as the inmate population continued to rise and facility conditions continued to decline. The last three years of operation saw two large-scale riots. (IDSC-BSU 1/19/1973.)

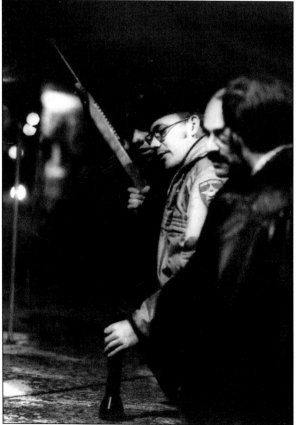

On March 7, 1973, inmate Larry Ramos Trujillo was escorted from the new maximum security prison south of Boise for medical attention at the older penitentiary facility. After prison staff attempted to return Trujillo to the new prison, he claimed his wounds were the result of abuse by guards there and refused to leave. Rumors about his injuries spread quickly and chaos ensued. (ISHS p1986-49.)

Law enforcement officials discuss the rising tensions in the prison yard in 1973. One former penitentiary guard remembered how quickly the tensions escalated: "The fires got going. . . . It was scary." The riot did not cause any injuries or deaths but did an estimated $100,000 worth of damage to four buildings, all built around the turn of the 20th century. (IDSC-BSU 3/7/1973.)

Inmates pose in solidarity. Larry "Louis" Trujillo, center with towel, triggered the 1973 riot after sustaining injuries at the new correctional facility. Prison officials argued Trujillo's broken arm, visible in this photograph, was self-inflicted, but inmates believed it was broken by guards at the new site. The damages sustained during the riot hastened the facility's closure. All inmates were transferred to the new site by December 1973. (IDSC-BSU 3/8/1973.)

This 1973 riot photograph shows inmates with items stolen from the prison commissary. Prisoners not wanting to be implicated during the riot gathered near the deadline by the wall. Pillaging inmates tried to lure them into the riot by throwing stolen items at them. At center, an inmate walks through the Main Yard with a kitten on his back. Normally, inmates were not allowed to keep cats. (IDSC-BSU 3/7/1973)

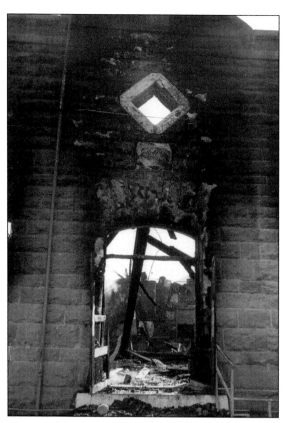

The chapel services sign remains after the 1973 riot left the oldest building on the site, constructed in 1870, in ruins. The chapel, along with four other buildings, was set on fire within the first three hours of the riot. Prior to its destruction, meetings and church services for many denominations were held here. (IDSC-BSU 3/8/1973.)

Fire was ignited in the kitchen and spread through the interior of the Dining Hall, destroying the building in the 1973 riot. In 1898, inmate George Hamilton designed the structure. The warden, proud of Hamilton's design, arranged for his pardon under the condition he leave the state. Addicted to alcohol and morphine and distraught at the thought of leaving, Hamilton died of an overdose the day after his release. (IDSC-BSU 3/7/1973.)

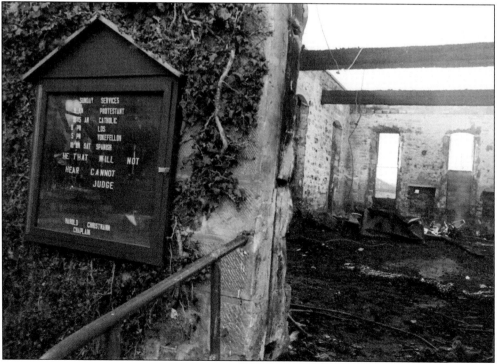

Seven

FELONY FACES, ENFORCEMENT EXPRESSIONS

Between 1872 and 1973, over 13,000 inmates spent time confined inside the walls of the Idaho State Penitentiary. A total of 215 women served time at the penitentiary. Inmates came from all walks of life, and each had a unique story to tell. Political party leaders, bankers, farmers, and troubled youths all shared quarters at the Idaho penitentiary. Former inmates Eveline Clark and George Hamilton entered the prison addicted to morphine and alcohol. Josie Kensler birthed her third child at the site. Countless stories of inmates' pasts are forever bound to the historic prison and offer a glimpse into American society's shift in ideas of social justice.

Inmate stories, however, do not tell the complete story of the prison. Over the 101 years of prison operations, thousands of guards, and 36 wardens, diligently watched over troubled men and women. In 1915, Warden John Snook wrote a letter to Ferdinand Fackrell offering him a position as guard at the penitentiary. Fackrell, a former deputy sheriff and police officer, earlier lost his foot while performing duties as an officer. "Your appointment as guard still holds good with me," wrote Warden Snook, "You can get an artificial foot and fill the position here." Fackrell humbly replied, "It will be several months before I will be able to wear an artificial leg, but will be very glad to have the position."

It is the individual stories of these felons and lawmen that allow one to better understand the significance of the Idaho State Penitentiary. Their faces provide an opportunity to see the effects of crime and subsequent penitentiary life.

An appointed US marshal acted as warden at the Idaho Territorial Prison until statehood in 1890. US marshal and later senator Fred Dubois encouraged the incarceration of polygamists, typically followers of the Church of Jesus Christ of Latter-day Saints (Mormons) at the time. Dubois's anti-Mormon campaign led to massive overcrowding at the prison, triggering the construction of a new cell house to accommodate the influx of inmates. (ISHS 1148-6.)

Orlando "Rube" Robbins served 25 years as a deputy US marshal. Between November 1892 and January 1893, he acted as warden to fill a temporary vacancy. Robbins eventually earned positions as Boise chief of police and sheriff of Ada County in Idaho. During his illustrious career in law enforcement, Robbins defined the standard of law and order in Idaho Territory. (ISHS 627.)

Tennessee native John Hailey ventured west on the Oregon Trail at 18 years of age. From 1899 to 1901, Hailey was the warden of the Idaho State Penitentiary. During his short administration, he managed the prison with less expense than previous wardens. In 1907, he became the first secretary and librarian of the Idaho State Historical Society, working to develop the agency until his death in 1921. (ISHS 86-A.)

Arrested originally for robbery, Alfonso James Cross committed a double murder on his way to trial, killing the men who were the state's witnesses against him. Known as the "Hagerman Murderer," Cross was pardoned in 1907 for being a model prisoner. After his release, Cross drew plans and specifications for stone and steel work for the penitentiary, earning $112 for his efforts. (ISHS Inmate No. 376.)

Harry Gordon was sentenced to life in prison for the murder of Emmett Fox. Gordon was spared the death penalty because officials thought his partner fired the fatal shot. After his conviction, it was discovered Gordon actually fired the gun. Granted a pardon in 1910, Gordon served over 16 years and was the prison's oldest inmate at 40 years of age. (ISHS Inmate No. 480.)

James Armstrong spent six years at the penitentiary for robbery. During his stay, he had three turns in the dark cell; the first two were for failed escape attempts and the third for assaulting another inmate. He was released in 1901. Armstrong's alias was John T. Hines, so he was often confused with another inmate serving at the time, John F. Hines. (ISHS Inmate No. 536.)

In October 1896, John Kensler disappeared, and many suspected Kensler's wife, Josie, and his hired man, Al Freel. In December, officials found Kensler's body and arrested the suspected lovers and murderers. Both parties adamantly denied the accusations. Myrtle Kensler, Josie's nine-year-old daughter, testified that Josie and Al were both present in the house the night John disappeared. The jury found them guilty of murder. Prison punishment records reveal Freel often fought inmate William Thomas over Josie's affections. In 1897, eight months pregnant with her third child, Josie gave birth to the first baby born at the penitentiary. Freel's sentence was later commuted, but Josie continued to stir controversy. In 1902, she became pregnant by a prison employee; the warden and the prison doctor conspired and successfully aborted her child. (Above, ISHS Inmate No. 564; right, No. 565.)

Convicted of grand larceny in Owyhee County, Sam Bruner gained trusty status at the penitentiary. He was stationed at the steam power plant outside the walls. On December 30, 1901, Bruner concocted an escape plan. After a routine check, Bruner and the fastest prison horse, Old Selam, turned up missing; Bruner was never seen again. (ISHS Inmate No. 723.)

Harry Daugherty served two sentences in the penitentiary. After serving a full sentence for his first burglary, Daugherty escaped four months into his second sentence while working outside the walls. In 1911, Daugherty was found in the Colorado prison system under the alias H.L. McLey and transferred back to Boise to serve the remainder of his original time plus additional time for the escape. (ISHS Inmate No. 736.)

Received in 1900, Dr. R.J. Alcorn served less than two years for the death of Cora Burke. On June 21, 1899, Dr. Alcorn performed a surgical abortion resulting in Burke's death two days later. Convicted of manslaughter, Dr. Alcorn ran the dispensary while incarcerated at the penitentiary. He was paroled in 1902 and returned to Kootenai County. (ISHS Inmate No. 739.)

George Lamoreau led an exemplary life and was respected by the public. After being elected Ada County clerk and recorder, Lamoreau began misusing his power, living his life by gambling and becoming a known adulterer. When Lamoreau's accounts were examined, he was arrested for embezzlement of public funds. Convicted and sentenced to seven years, he was released early for good behavior. (ISHS Inmate No. 751.)

In 1899, Bert Hillman (above) and Dan Harkins (below) walked into the American Development and Mining store and office in Gibbonsville, Idaho. After a few minutes of small talk, Hillman pulled a six-shooter and calmly said, "Well, you fellows might as well throw up your hands. We are going to rob this institution." Captured a few days later, both men were sentenced to five years in the penitentiary. In August 1901, while Hillman was working in the quarry, he escaped through a cavern and eluded authorities for nine days before he was captured. A year later, Harkins propped a long board against the wall and climbed over. Immediately a search party, including bloodhounds, was sent out, but they lost Harkins's scent. Hillman was released in August 1906 after completing his sentence. (Above, ISHS Inmate No. 766; below, No. 767.)

In April 1900, the *Idaho Statesman* described Alfred Roberts, a musician at a local piano parlor, as having "a very Frenchy way about him, dressed at the height of fashion and perfumed himself loudly." Roberts created a detailed scheme to forge checks and money orders around town. While incarcerated at the penitentiary, Roberts served as steward and waiter at Warden Charles Arney's house. (ISHS Inmate No. 770.)

Convicted in 1898 of killing a fellow Chinese man in Hailey, Yee Wee adamantly denied the accusation. At his trial, a translator incorrectly told the court that a statement written by Yee admitted his guilt. A different translator later stated that the document contained no admission of guilt. Gov. Frank Steunenberg twice delayed Yee's execution. Finally, in 1906, the state fully pardoned him. (ISHS Inmate No. 771.)

In October 1900, Carnemoraqui, or Carmoroqui, began his sentence at the penitentiary. Convicted of cattle rustling (stealing), the 80-year-old Native American and member of the Lemhi tribe became the oldest inmate at the site. In January 1902, the pardon board decided to release the elderly man to the care of his family in Custer County. (ISHS Inmate No. 785.)

Robert Roman served a complete three-year sentence for grand larceny. In 1908, Roman attempted to hold up the Great Northern westbound fast mail train No. 3. After a shootout with the conductor, Roman was shot in the lungs. Hopping off the train, he was captured near Naples, Idaho. Roman returned to the penitentiary to serve 14 years for assault with intent to commit robbery. (ISHS Inmate No. 819.)

Ida Laherty stole a team of horses from Moscow, Idaho, in 1902. Laherty, 15 years old, became the youngest female inmate to be incarcerated at the penitentiary. She only spent three months in a cell segregated from the male prisoners before she was released. The Women's Ward had not been established at that time. (ISHS Inmate No. 901.)

Susie Duffy was sentenced to three years and four months for grand larceny in April 1903. The evidence for her conviction was not very strong and with deteriorating health, her parole was petitioned. Duffy was released in March 1905 on the condition she return to her parents in Kansas City. With little hope for recovery, Boise's African American community collected the money for her ticket home. (ISHS Inmate No. 917.)

Charles Smith (No. 942) was sentenced in October 1903 for forgery. In May 1905, Smith ran away while working outside the walls. Hounds tracked him to the Boise River, where he was assumed drowned. In 1940, Smith reemerged in Coeur d'Alene, revealing his identity to police in an effort to "ease his conscience." Burglar George Prince sits next to Smith. Shared mug shots saved the state money. (ISHS Inmate No. 942, No. 943.)

In 1905, Caddie Shoup entered the penitentiary. Caddie's lover promised to marry her but moved in with another woman instead. Feeling betrayed, she killed her one-time love in the bathtub and attempted to make it look like a suicide. During the trial, jurors admitted feeling sympathy for Shoup, but they ultimately found her guilty. She served three years, one month, and one day for voluntary manslaughter. (ISHS Inmate No. 1146.)

A.E. Love—a man with multiple incarcerations and even more aliases—was confined at the prison twice for burglary convictions. Once considered among the most dangerous men in custody, Love escaped in 1906, committing crimes across the Midwest for two years until he was caught and returned to Idaho. In 1911, due to an incurable disease, Love was released with less than a year to live. (ISHS Inmate No. 1141.)

Arthur Allen served nearly four years at the penitentiary for stealing one ham, three jars of fruit, and one copper wash-boiler. Ada County residents suspected Allen and his wife of being part of a much larger theft ring. The stolen ham was entered into evidence and used in the courtroom to prove their guilt. (ISHS Inmate No. 1186.)

Perhaps the most infamous prisoner at the penitentiary, Albert Horsely (also known as Harry Orchard) assassinated former governor Frank Steunenberg with a bomb blast in Caldwell, Idaho. While imprisoned, Orchard was baptized in the plunge bath beneath the Dining Hall. He also wrote a book entitled *The Man God Made Again*. The late governor's wife and son visited Orchard on several occasions after his religious conversion to the Seventh-Day Adventist Church. Steunenberg's son, Rev. Frank Steunenberg, stated, "The assassination is a matter of the past. . . . [Orchard] has made peace with his God, and goes about his duties as attendant of the prison poultry farm calmly awaiting the end of his days." As a trusty with rare privileges, Orchard raised chickens and turkeys near his cottage outside the walls. (Left, ISHS Inmate No. 1406; below, p1986-49.)

In 1908, Cora Stanfield pleaded guilty to adultery despite the fact that she was legally separated from her husband. Stanfield received a sentence of nine months in prison and, in 1909, a full pardon. As of 2014, adultery is still a crime in Idaho, though rarely enforced. (ISHS Inmate No. 1482.)

In 1832, the US Congress passed a law prohibiting the distribution of liquor on Indian lands. In 1908, James Shaw (No. 1499) and Edward Cassen (No. 1500) were convicted of doing so on the Nez Perce Reservation in north Idaho. Both men were fined $300 and sentenced to 14 months. (ISHS Inmate No. 1499, No. 1500.)

Thirty-six men served as warden at the penitentiary. John Snook worked from May 1, 1909, through December 31, 1916. He again took the reins from July 24, 1924, through January 15, 1925. Snook believed firmly in keeping able-bodied inmates working. "Failure to furnish some useful and productive form of industry," Snook asserted, "makes a permanent idler of him who was once industrious." (ISHS 68-57-43.)

Albert Leahy arrived at the Idaho State Penitentiary on March 5, 1912, for the crime of embezzlement. Leahy misappropriated $600 for his personal use from his employer. He admitted his guilt and stated he fully intended to pay back the company. Leahy's girlfriend promised to wait for him, and although she could not come to Boise when he was released, she met him in Nampa. (ISHS Inmate No. 1890.)

Barney O'Neil was incarcerated in 1913 for making a false report. O'Neil moved west from New York City and became involved in several failing investments, including the State Bank of Wallace. Prior to incarceration, O'Neil had been chairman of the State Republican Party and a candidate for both the US Senate and governor for the state of Idaho. (ISHS Inmate No. 2064.)

In March 1910, Fred Gruber was sent to prison for murdering a man in Coeur d'Alene. Gruber escaped in November 1918 by braiding 25 feet of Red Cross yarn used by inmates to knit sweaters for soldiers and using it to scale the wall. A year later he was returned after being arrested for automobile theft. (ISHS Inmate No. 1665.)

Dollie Underwood and Harry Hinton robbed a chauffeur at gunpoint in Sandpoint, stole his car, and headed to Spokane, Washington. Dollie adamantly denied being a participant in the car theft. She blamed "Boob reporters with a desire for sensational newspaper stories," for her incarceration. The *Idaho Statesman* rather coolly reported that "Mrs. Underwood would not be a bad looking woman were it not for these scars." (ISHS Inmate No. 2326.)

On September 1, 1917, Ellen Pappas, whose real name was Ella Deyatt, and two other women stole a car in Bingham County. After pleading guilty, Pappas served four months at the penitentiary. On January 15, 1918, the state granted her a pardon on the condition she rejoin her parents in Rock Springs, Wyoming, and stay out of Idaho for at least three years. (ISHS Inmate No. 2540.)

Fred Schmidt (above) was sent to prison in 1917 for committing grand larceny in Bannock County. Fred and his brother Otto (below) stole and butchered a calf belonging to a rancher near Inkom, Idaho. Fred became a model inmate. Warden Frank DeKay called him his "very best prisoner" and recommended he be pardoned. On November 20, 1918, he was granted an unconditional pardon that would take effect on December 24, 1918. Fred made plans to spend a happy Christmas with his wife and two children in Pocatello. Unfortunately, he never made it home. He died from influenza two days before his release. (Above, ISHS Inmate No. 2583; below, No. 2584.)

Prisoners routinely performed minstrel shows at Christmas time for other inmates and visiting dignitaries, including governors and prison officials. These shows consisted of white performers appearing in blackface. Popular during the early 20th century, minstrel shows perpetuated racial stereotypes by portraying black Americans in a derogatory way. (ISHS 73-229-2-nnn.)

Hannah Folden was convicted of "possession of intoxicating liquor after prior conviction" in 1922. During the Prohibition era, the US Constitution made it illegal to produce, distribute, and consume alcohol. Deputies found alcohol at Folden's business in Sandpoint, Idaho. She tried to bribe the deputies with $50 to replace the moonshine with water. (ISHS Inmate No. 3281.)

On August 10, 1925, Wana Wilson (above) met a traveling circus employee, Jess Wilson (no relation). The two proceeded to consume wood alcohol and other drugs. Under the influence of drugs and alcohol, Jess robbed an elderly man and another woman at gunpoint while Wana looked on. The two were arrested, convicted of robbery, and sent to the penitentiary. (ISHS Inmate No. 3542.)

On December 20, 1927, Jeannette Benoy shot and killed her husband, Tom, at their home in Stites. A.J. Stuart, a former pastor, wrote a letter to the governor on behalf of Jeannette. Stuart claimed of Tom's three known wives, the first went insane from his repeated abuse, and the second left him after he severely beat her. She died of internal injuries days later. (ISHS Inmate No. 3919.)

Champion boxer Jack Dempsey visited the penitentiary in 1931. He came to Boise in September for an exhibition fight at the fairgrounds. The reason for Dempsey's visit to the prison remains a mystery to current Old Pen staff. Other celebrities visited the penitentiary, including actress Ethel Barrymore, who came in 1907 to see Harry Orchard after he testified against labor boss William "Big Bill" Haywood. (ISHS m511-955-jack-1.)

Angela Hopper embezzled from the city's tax assessments for years. By the time she was caught in 1933, between $85,000 and $100,000 was missing. She served about five years, longer than many women who were sentenced for murder or manslaughter. At her trial, her lawyer asked for a sentence of parole and defended her by saying she had used none of the money for herself. (ISHS Inmate No. 4860.)

On March 29, 1933, Gilbert H. Talley began working as a guard, eventually earning the rank of captain of the yard. In September 1958, nine inmates held 77-year-old Talley and others hostage in No. 4 House. The inmates demanded better conditions from Warden Lou Clapp. The hostages were released without injury. Talley died in 1968 after a long career at the penitentiary. (ISHS 3527.)

Mary Mill's crime was "exposing another person to the infection of a dangerous disease." She entered the Women's Ward in 1935, and prison documents report, "she has no criminal tendency except she seems to have no moral standards whatever, and has no compunction as to her acts or what she does." (ISHS Inmate No. 5231.)

LESLIE PEARSON ALBERT J. DAWSON HARRY ROARK VIRGIL CARY

Guards came from many different backgrounds. Some began in law enforcement, a natural transition to the prison system. Others had no previous training, forcing them to adapt quickly. Low retention rates made long careers rare. Virgil Carey, however, enjoyed a long career and climbed the ranks from guard to lieutenant. Other guards survived deadly situations. Harry Powers worked for over 30 years as a prison guard. In January 1943, inmate Danny Williams overwhelmed Powers and stole his pocketknife and then stabbed him in the neck and attempted to escape. Powers slowly recovered and eventually retired. In 2013, Harry's family visited the penitentiary and shared stories about his time as a guard. Powers, they claimed, took trusty inmates to his Boise home, where they helped him with improvements on the property. (Above, ISHS p5002-2-54-9; below, p5002-2-54-9a.)

JESS E. SMITH WILLIAM A. MURPHY EZRA MENDENHALL MORRIS E. RACE HARRY POWERS

Woffie Bitt was convicted of forgery in 1945. Bitt worked for Delphin Coig in Bruneau. After leaving her job, she took blank checks and forged his signature. Bitt ended up cashing two $300 checks. She served four months in the Women's Ward before being released and eventually pardoned. (ISHS Inmate No. 6857.)

At 17, Verna "Tarzan" Keller murdered Bonnie Plaster in an alley for flirting with Verna's boyfriend. A few months after her arrival at the prison, she and another inmate escaped. Verna hoped to see her father but escaped mainly to prove she could. Warden Clapp picked them up in Ontario, Oregon, after they called him at home—collect—to find out if he was looking for them. (ISHS Inmate No. 7282.)

In 1949, Elizabeth Lacey's daughter pleaded with her mother to return to Idaho from Utah. Her daughter claimed Lacey's ex-husband beat and sexually abused the children. Two days after returning, she killed her ex-husband by poisoning his whiskey with strychnine. Elizabeth was the only woman convicted of first-degree murder at the Idaho State Penitentiary. On December 21, 1962, she was released after serving over 13 years. (ISHS Inmate No. 7610.)

In 1953, Lena Proud served time for providing an abortion to a young woman. Desperate women from Idaho and Oregon came to Proud to undergo the procedure or for help finding homes for their illegitimate children. The judge advised, "She should be made an example of as a warning for such operations." One of the oldest female inmates ever, Proud was released less than a year later. (ISHS Inmate No. 8760.)

All inmates received standard-issue clothing when they arrived at the penitentiary. Only under special circumstances, with written permission from an official, could prisoners wear personal clothing. Here, two prison employees, including assistant chief clerk Robert M. Johnson (left), jokingly adorn the prison uniform of one of the larger inmates. (ISHS P18-4.)

Closed-circuit television monitors assisted overworked guards at the understaffed penitentiary. These monitors were closely watched by the turnkey guard in the Administration Building. The turnkey guard was almost solely responsible for admitting visitors and for allowing inmates and guards to come and go between the Main Yard and outside the prison walls. (IDSC-BSU 12/14/1966.)

Orvil Stiles served as the prison chaplain and briefly as warden. In a 1987 *Los Angeles Times* interview, Stiles remembered September 15, 1967: "I gathered all the prisoners together and announced that no one would be confined any longer in Siberia. I told the prisoners if a dog had been put in one of those cells, the humane society would have you jailed. I got a standing ovation." (ISHS p1986-49.)

In 1944, Louis Clapp began his 22-year tenure as warden. He believed people committed crimes out of choice rather than being driven by poverty. The warden's job was, in his view, to protect society from criminals, carry out society's sentence, and rehabilitate the inmates who wanted to be rehabilitated—in that order of priority. Nevertheless, Clapp fought for educational and vocational programs. His reforms primarily benefitted male inmates. (ISHS 42.)

On Sunday, December 28, 1958, three women escaped from the Women's Ward. Warden Clapp identified the escapees as Virginia Pugmire, 22 (below); Mary Ann Gardner, 21; and Nancy Christopher, 26 (right). All were imprisoned for forgery. The three locked up the other women prisoners in their cells, threatening them if they notified the guards. Virginia Pugmire was captured near Kimberly, Idaho, shortly after the escape. On January 3, 1959, Mary Ann Gardner went to California to see her father. Once she arrived, her father called Warden Clapp and insisted on driving her back to Idaho. Gardner was at her home for only an hour and a half before her return trip back to Boise. On January 9, thirteen days after the escape, Nancy Christopher was arrested in Austin, Texas. (Right, ISHS Inmate No. 10101; below, No. 10587.)

The tunnel area of the Administration Building at one time contained only two wooden gates and had a dirt floor. Wagons carried sandstone quarried by inmates through this area. In the 1930s, the interior gate along the wall was taken out, filled in with stone, and a sliding door was added. In this 1950s photograph, a soda machine for guards sits just to the left. (ISHS p1986-49.)

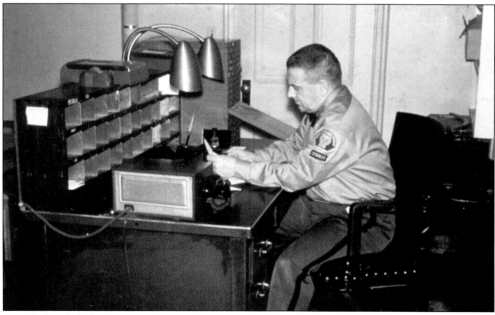

Guards faced daily dangers. They could not carry a firearm in the prison yard but kept a sap or nightstick on their belt for protection. Often undertrained and overworked, most guards did what they could to maintain order, treat inmates fairly, and stay safe. Guards, however, could not escape mundane tasks like filing and reviewing paperwork. (ISHS p1986-49.)

Eight

LEGACY

In 1974, less than a year after the last inmate exited the sandstone fortress, the Idaho State Penitentiary was listed in the National Register of Historic Places. The honorary distinction did not stop some politicians and citizens from proposing the site be demolished and the prime real estate sold to the highest bidder. Instead, the Idaho State Historical Society inherited the property for use as a museum. Former guards and inmates often led tours through the site. The "Old Pen," as it was soon referred to by nearly all Boise residents, developed educational tours and other programming for the onslaught of visitors.

The Old Idaho Penitentiary adapted quickly as a destination museum in the west. On September 10, 1996, the site hosted rockers Rage Against the Machine. The Idaho Army National Guard conducted field training near the site and at Outlaw Field. In 2009, Old Pen staff planned the first-ever "Frightened Felons" Halloween, an annual after-hours event.

As of 2014, the site continues to be one of only four territorial prisons open to the public. Approximately 5,000 school-aged Idaho students visit the site to better understand Idaho's history of social justice. Over 40,000 total visitors walk through the barred doors and venture inside the sandstone fortress every year.

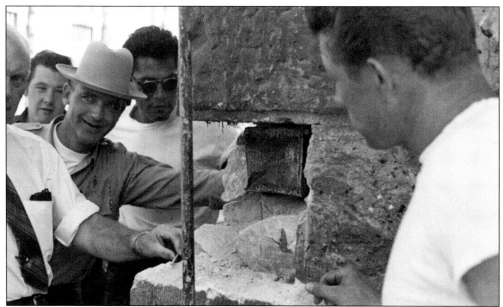

On July 4, 1870, at 6:00 p.m., a lead box was enclosed in the cornerstone of the Territorial Cell House. The cornerstone contained many "rare and curious trinkets" according to a July 7, 1870, *Idaho Tri-Weekly Statesman* article. The citizens of Boise contributed 25 packages to be tucked away for future generations to study. These Chinese coins were included in the time capsule, along with other gold, silver, and copper coins and paper currency. The cornerstone was opened in 1970. Officials inspected the artifacts for the first time since they were sealed inside the lead box by prison contractors and employees. The contents of the cornerstone were donated to the Idaho State Historical Society. (Above, ISHS 70-57-1; below, IDSC-BSU 7/18/1970.)

Don Samuelson only served one term as Idaho governor (1966–1970). In July 1970, he visited the Idaho State Penitentiary to unlock 100 years of mysterious curios from the cornerstone of the oldest building on site. With the warden, guards, and inmates watching, the governor oversaw the removal of the cornerstone and the opening its incased time capsule. The capsule contained 10 newspapers from 1870, including the July 2, 1870, edition of the *Idaho Tri-Weekly Statesman*. Newspapers from California and Ohio were also included, along with almanacs, lists of public officials and Masons, political nominees from local elections, Chinese coins, and other memorabilia. (Both, IDSC-BSU 7/18/1970.)

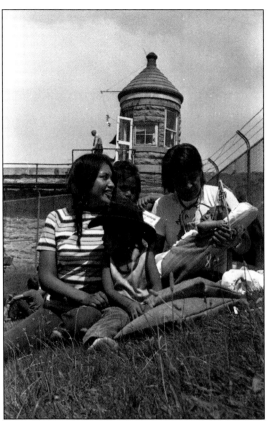

Citizens relax on a grassy slope inside the penitentiary's No. 2 Yard in 1972 to watch the daylong festivities of a field meet that included barrel racing, pole bending, a potato race, calf tying, sky diving, Indian dancing performed by the North American League, and a guest appearance by recording artist Frank Starr. (IDSC-BSU 8/19/1972.)

As Idaho's capital city grew, it inched closer to the once-isolated prison site. In the background to the right, the capitol building and the East End neighborhood can be seen. Also visible in the foreground are a chicken coop/storage shed, garden, and a vocational and education center. In the 1990s, the Idaho Botanical Garden razed the dilapidated buildings. (ISHS p1986-49.)

In the late 1930s, with the assistance of the Works Progress Administration, the condemned Territorial Building was transformed into the Prison Chapel. Visiting pastors and church choirs helped the appointed chaplain minister to inmates. The piano, visible to the left, is now on exhibit at the Old Idaho Penitentiary. The chapel burned in the 1973 riot. (ISHS p1984-15-28.)

In 2010, the University of Oregon's Pacific Northwest Preservation Field School conducted training at the Old Idaho Penitentiary. It completed masonry and window restoration projects in an effort to preserve the northwest guard tower. The towers, erected along with the wall between 1893 and 1894, serve as stark reminders of the dangers guards and inmates faced inside prison. (ISHS p5002-2.)

By 1975, the Idaho Department of Corrections (IDOC) transferred administration of most of the penitentiary site to the Idaho State Historical Society and a handful of other state agencies. IDOC did maintain control of the Guard House, 1950s Warden's House, and the Probation and Parole Building. The Boise District 4 Probation and Parole satellite office still occupies 2161 Old Penitentiary Road. (ISHS p1986-49.)

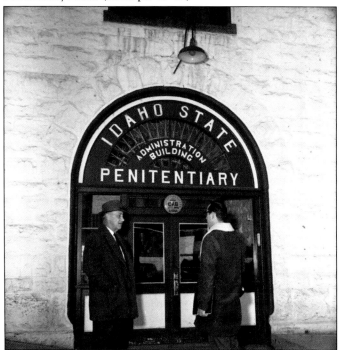

Since the 1930s, the entry to the Idaho State Penitentiary's Administration Building has remained largely unchanged. Seen here in 1966, every one of the penitentiary's 13,000-plus inmates stepped through these doors at one time. In 2012, the Idaho State Historical Society renovated and painted the doors and entryway. (IDSC-BSU 12/14/1966.)

Perched high above the southwest Idaho desert near Kuna, this guard tower at the Idaho State Correctional Institute made any escape attempt by foot nearly impossible. Here, the current Idaho correctional facility is shown during early stages of construction in the 1960s and early 1970s. The facility's location was selected because of its distance from the city, availability of land, and expanse of open space. (IDSC-BSU 1961.)

The new correctional facility, called the "New Pen" by Boise residents, was completed in 1972. The facility was built in the sagebrush-filled desert south of town on Pleasant Valley Road. Maximum security inmates were the first to be relocated; the remainder of the population followed the next year. (ISHS p1984-15-44.)

The Warden's House, the Administration Building, and the geologic formation Table Rock serve as the backdrop to a warden's family tennis game. The view has changed little since this picture was taken in the early 1900s. Completed in 1902, the Warden's House contained eight rooms and a basement. Total cost to construct the sandstone house was $3,100. The state saved almost

$4,000 by using inmate labor. As of 2014, the building serves as offices and is occupied by the Idaho Commission on the Arts. The Old Idaho Penitentiary State Historic Site is open to the public year-round, seven days a week. (ISHS 66-108-5.)

DISCOVER THOUSANDS OF LOCAL HISTORY BOOKS FEATURING MILLIONS OF VINTAGE IMAGES

Arcadia Publishing, the leading local history publisher in the United States, is committed to making history accessible and meaningful through publishing books that celebrate and preserve the heritage of America's people and places.

Find more books like this at
www.arcadiapublishing.com

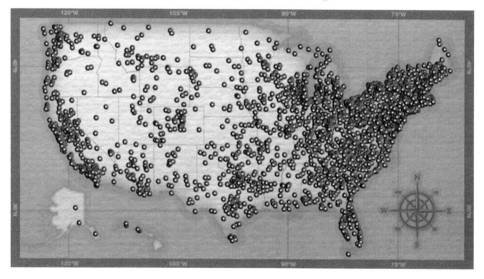

Search for your hometown history, your old stomping grounds, and even your favorite sports team.

Consistent with our mission to preserve history on a local level, this book was printed in South Carolina on American-made paper and manufactured entirely in the United States. Products carrying the accredited Forest Stewardship Council (FSC) label are printed on 100 percent FSC-certified paper.

MADE IN THE USA